Cover:
DAVID BOMBERG (1890-1957)
52. *Study for "Sappers at Work:
A Canadian Tunnelling Company"*

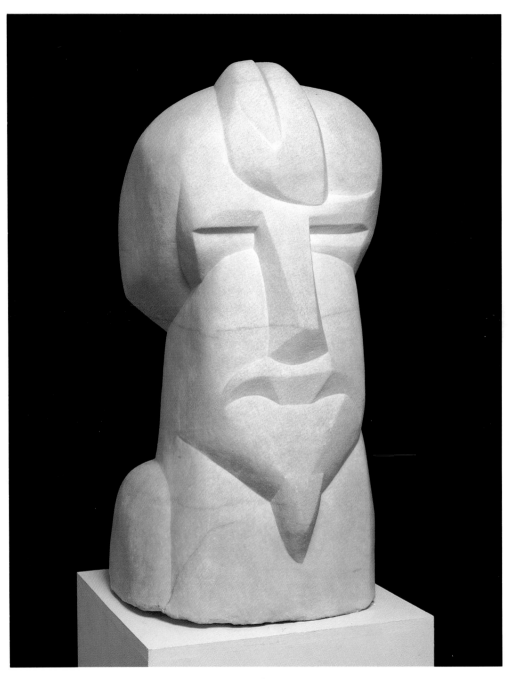

HENRI GAUDIER-BRZESKA (1891-1915)
71. *Hieratic Head of Ezra Pound*

BRITISH MODERNIST ART
1905-1930

November 14, 1987-January 9, 1988

Hirschl & Adler Galleries, Inc.
21 East 70th Street, New York, N.Y. 10021

Photograph on p. 6 by Howard Grey.
From *Omega & After: Bloomsbury &
The Decorative Arts*, by Isabelle
Anscombe (Thames & Hudson).

Acknowledgements

British Modernist art is generally unknown in the United States. Such an oversight made the idea of organizing an exhibition of this material particularly appealing to us. We present here a selected group of works—paintings, drawings, prints, sculpture, and decorative objects—that illuminate highlights of British Modernism from about 1905 to 1930. Our selections fall into three main categories: The Camden Town Group, The Vorticists, and Bloomsbury. Our central objective is to offer a fundamental overview and introduction to these aspects of British art.

Hirschl & Adler has dealt extensively with American Modernist work. Our involvement with British counterparts, however, has been limited. In 1967 the gallery organized a Walter Richard Sickert show, and we are pleased to be able to bring this initial foray up-to-date with *British Modernist Art, 1905–1930*. Our efforts have been greatly facilitated by various institutions, galleries, and individuals who assisted with a myriad of organizational details. We would like to thank first and foremost Anthony d'Offay and Matthew Marks, who conceived and co-organized the exhibition. In addition, Marie-Louise Laband, Lorcan O'Neill, and Robin Vousden, at Anthony d'Offay Gallery, greatly assisted in the project, as did Richard Shone and Judith Collins, Curator at the Tate Gallery, London. Mr. and Mrs. Samuel Barclay, Angelica Garnett, Henrietta Garnett, and Frederick Gore, all members of the artists' families, were also very helpful. The cooperation of the Fine Art Society, Browse & Darby Ltd., and James Kirkland, Ltd., all in London, enhanced the diversity of the exhibition. At Hirschl & Adler Galleries we would like to thank Vance Thompson, Mary L. Sheridan, Meredith Ward, Monica Moran, Susan E. Menconi, and Anne Birle for their help in administrative matters and with the production of the catalogue. Finally, we thank William S. Lieberman for contributing the preface to our catalogue.

Douglas Dreishpoon
James L. Reinish

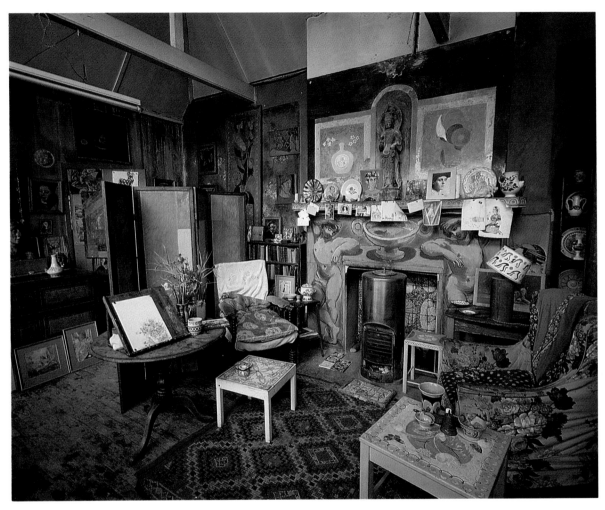

Duncan Grant's Studio at Charleston

Preface

It is a presumption but nevertheless a pleasure to contribute a preface to this catalog of the exhibition *British Modernist Art: 1905-1930* at the Hirschl & Adler Galleries. For a New York audience the selection sparkles with individual surprises, but it should be enjoyed as an entity, as an informal but informed introduction to three currents in British art that coexisted during the first decades of the 20th century.

Last January in London, an extensive exhibition opened at the Royal Academy of Arts. That survey focused on some seventy British artists working from 1900 to today. It defined and illustrated the development and continuity of British modernism. Successful in every way, the Academy's exhibition attracted international response, and a version was afterwards shown in Stuttgart. A related, more encyclopedic survey devoted solely to sculpture had been previously presented at the Whitechapel Art Gallery in London in 1981. The Academy exhibition, however, was broader in scope, and it joined painting, sculpture, and drawing. Alas, none of this was seen in the United States. How fortunate, therefore, that this present exhibition is organized specifically for New York.

The selection features three concurrent associations of artists born during the last decades of the 19th century: the Camden Town Group, the shorter lived Vorticist circle, and the Bloomsbury coterie. The last, better known for its literati, lived longest, and its later years are best represented in the United States by paintings recently collected by Reader's Digest. The exhibition at Hirschl & Adler, however, includes only works from Bloomsbury's early years, and it also indicates the Bloomsbury artists' concern with decorative arts. Today, in retrospect, these three crosscurrents, Camden Town, Bloomsbury, and Vorticism, seem to complement rather than contradict one another.

Forty years ago the work of contemporary British artists was virtually unrecognized in the United States, with one notable exception. In New York, at the Museum of Modern Art, one might sometimes see single examples of sculpture by Jacob Epstein, Henri Gaudier-Brzeska, and Barbara Hepworth, who was born in 1903. One might also see single paintings by Stanley Spencer, Ben Nicholson, and John Tunnard, all born at the turn of the century. Forty years ago, however, the Museum's representation of British art was erratic. Camden Town, Bloomsbury, and even Vorticism were unseen. The exception of course, was Henry Moore. Between 1937 and 1947, MOMA's founding director, Alfred H. Barr, Jr., collected four of his sculptures, and in 1946, also at the Modern, James Johnson Sweeney organized a Moore retrospective. Moore, however, was born in 1898. By the time of his first solo exhibition thirty years later in London, Camden Town, Vorticism, and Bloomsbury had flourished, and they had already established roots of British modernism.

Walter Sickert, the senior of the Camden Town group, was born in 1860. An extraordinary painter and a marvelous etcher, his works were collected for the Museum of Modern Art between 1955 and 1970 by Alfred Barr and myself. The other Camden Town painters Robert Bevan, Harold Gilman, Charles Ginner, and Spencer Gore were born later, between 1865 and 1878. Their interest in everyday life and in the urban scene as well as landscape might be compared to the "Ashcan" artists of New York. Camden Town, fortunately, was not their restricted subject.

For most Americans, the phenomenon of Bloomsbury is literary. It included in its nest two Woolfs, at least two Bells, a Strachey and a Keynes. Roger Fry, whose biographer was Virginia Woolf, was in some ways the father figure of Bloomsbury. (He also briefly served as curator of paintings at the Metropolitan Museum of Art.) Returning to England in 1908, he became the British champion of Cézanne and the Post-Impressionists, whose work he presented in publication and, importantly, in exhibition. Fry himself wanted to be known as a painter, and he was also the moving force behind the cooperative of Bloomsbury artists called the Omega Workshops. Bloomsbury, at least painterly Bloomsbury, left London in 1916 when Vanessa Bell (Virginia's sister) moved to Charleston in Sussex with her younger husband (Duncan Grant).

In the 20th century, the machine and industry have been glorified and vilified. In this exhibition three of Jacob Epstein's crayon studies for his sculpture *Rock Drill* (1913-14) specifically develop a mechanical theme. The three sheets are essential to an understanding of his sculpture. They describe his original conception, which was realized but subsequently destroyed: the life-size figure of a laborer operating a vibrating pneumatic drill. Epstein's first version celebrated not only the power of the machine but also the dynamism of man.

Epstein's drawings for his furious figure anticipate, by a very few months, Vorticist theory, which erupted in publication in the summer of 1914. Wyndham Lewis and Ezra Pound joined as the polemicists for the movement, declaring Cubism stale and Futurism picturesque. Vorticism, in fact, derived from both. Through exhibition and accompanying propaganda, the impact of Futurism had been strong, even more than that of Cubism. Even cognoscenti in London confused Cubism with Futurism and Futurism with Vorticism. For instance, in December 1913, Edward Marsh confided to Rupert Brooke: "Another new light whom I met today is Wyndham Lewis. I am going to the Picture Ball, if you please, as a futurist picture designed by him!"

Unlike Camden Town or Bloomsbury, Vorticism needed a manifesto. In the first issue of the Broadside *BLAST*, Wyndham Lewis declared: "The Modern World is due almost entirely to Anglo-Saxon genius—its appearance and its spirit. Machinery, trains, steamships, all that distinguishes externally our time, came far more from here than anywhere else....Machinery is the greatest Earth medium: incidentally it sweeps away the doctrines of a narrow and pedantic Realism at one stroke." Against such certainty, it seems superfluous to observe that David Bomberg and Epstein were Jews and that Gaudier-Brzeska was French. Pound, of course, was an American, as was Epstein. And Lewis, himself, had been born on his American father's yacht cruising the coast of Nova Scotia. Nevertheless, the Vorticists in England, like Fernand Léger in France, believed that new and challenging subject matter existed outside the studio, in the city and in the paraphernalia of an industrial environment. Such theories were soon implemented by the real machines of war which some Vorticists portrayed and by which Vorticism itself died. William Roberts' early experience of Vorticism, however, remained an essential ingredient to his art throughout his life. He died in 1980.

Hirschl & Adler Galleries is to be praised; their exhibition is refreshing and welcome. We easily move from the rhythm of Edwardian times to the syncopation of a new jazz age. A certain intimacy connects many of the artists, and there are special relationships between several of them. For instance, both Duncan Grant and Wyndham Lewis exhibited with the Camden Town group in 1911. The supremacy of the School of Paris is not challenged, or defended.

William S. Lieberman

The Camden Town Group

The development of a modern school of painting in England began at the end of the nineteenth century and gained momentum during the Edwardian era. Within this gradual development, the American artist James McNeill Whistler became a central figure, who introduced new concepts of style and content. Whistler was the vehicle through which contemporary French ideas were disseminated, and his extended residence in London was an impetus for younger painters to reject *retardataire* precepts of the Royal Academy and the residual effects of Pre-Raphaelitism. The British public, accustomed to slick academic painting, preferred pictures that were "finished." They liked portraits to be glamorous, flattering to the sitter, and dignified, landscapes to be bathed in soft and diffuse light, and genre pictures to be narrative and didactic.

During the first decade of the twentieth century, English artists gradually began to assimilate the formal aspects of French Impressionism and contemporary European art they saw in the annual London exhibitions of the newly-founded International Society. When Walter Sickert returned to live in London in 1905, after spending several years abroad, a number of younger painters sought his guidance and expertise. Being familiar with contemporaneous Parisian developments and a friend of Edgar Degas, Sickert was a natural teacher. His more traditional depictions of the London music halls, Dieppe, and the canals and buildings of Venice (inspired by Whistler) were well known by the 1890's. The English public could appreciate the precision and clarity of his earlier work, but they were affronted by his more contemporary and provocative subjects. Female figures shown in dim interiors, in bed, dressing, or talking to a friend were subjects indigenous to French art by this time, but to the English they lacked modesty and decorum. Such themes, however, continued to preoccupy Sickert after his return to London. He often painted in Camden Town, a dilapidated district in north London, where models were readily available and studio accommodations inexpensive. Soon thereafter, Sickert was joined by his friend and fellow artist, Spencer Gore. Gore began to paint similar subjects, though, unlike Sickert, his work generally avoided innuendo and ambiguity.

Eventually, a small group of painters gathered around Sickert and began to exhibit their work in his studio in Fitzroy Street, just south of Camden Town. Harold Gilman, Robert Bevan, Spencer Gore, and Charles Ginner were the leading artists in the group. In 1911 they were joined by Augustus John and the American-born Wyndham Lewis. The Camden Town Group continued for only a few years and organized three exhibitions during this time before they were absorbed into The London Group—an organization that still exists today.

Among members of the Camden Town Group, aesthetic temperaments and stylistic approaches varied, but in many instances they shared common subject matter, a preference for unmodulated color, and a pictorial scale commensurate with their choice of intimate themes. Their subject matter varied from domestic interiors and portraits of friends to street scenes. Sickert and Gore shared a passion for theatre; Gore and Gilman, following Sickert's example, painted female nudes in domestic interiors; Ginner painted cityscapes in London and Leeds. Robert Bevan found his own thematic niche among the London cabyards and at the horse sales. During the summers, Gore, Gilman, and Bevan painted landscapes in the English countryside.

For the most part, the Camden Town painters eschewed the romantic inflections of Augustus John's work and Wyndham Lewis's satirical edge. Their fascination with candid depictions of life paralleled contemporaneous developments in America with artists of the "Ashcan School." Receptive to Impressionism and aspects of Post-Impressionism, they adapted a wider range of color and pursued new subjects. Ultimately, they assimilated some of the formal innovations of European art, which they incorporated into subjects that reflected mainstream English life.

ROBERT POLHILL BEVAN (1865-1925)

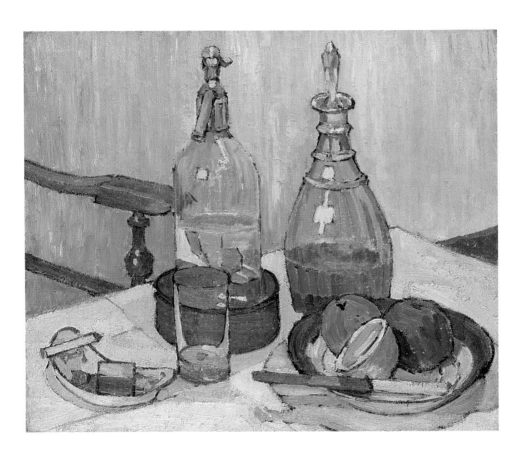

1. *Whisky and Soda*

Oil on canvas, 15 x 18 in.
Painted in 1914

RECORDED: R. A. Bevan, *Robert Bevan 1865-1925: A Memoir by his Son* (1965), p. 21 pl. 48

EXHIBITED: Southampton Art Gallery, England, 1951, *Camden Town Group*, [n.p.] no. 10 // Arts Council of Great Britain, London, 1956, *Robert Bevan 1865-1925*, [n.p.] no. 18 // P. & D. Colnaghi & Co., London, 1961, *Paintings by Robert Bevan 1865-1925*, [n.p.] no. 28 pl. IV // P. & D. Colnaghi & Co., London, 1965, *Robert Bevan 1865-1925: Centenary Exhibition*, [n.p.] no. 33 // Ashmolean Museum, Oxford, England, 1965, *Centenary Exhibition of Paintings, Drawings and Lithographs by Robert Bevan 1865-1925*, [n.p.] no. 33 // Yale Center for British Art, New Haven, Connecticut, 1980, *The Camden Town Group*, p. 6 no. 8 illus.

EX COLL.: the artist; to his estate, until 1974; to private collection, London, until 1987

All members of the Camden Town Group painted still lifes at one time or another. Whereas Harold Gilman and Spencer Gore generally preferred to depict humble domestic objects, such as lodging-house ornaments, Bevan gravitated towards more elegant props. Bevan's friendship with Paul Gauguin, whom he had met at Pont-Aven in 1893, greatly influenced his development. In *Whisky and Soda*, his awareness of Gauguin's art is reflected in his choice of perspective, crisp linear contours, and bold colors.

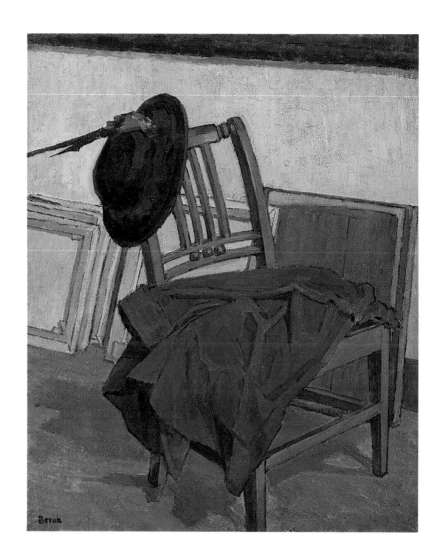

2. *The Green Coat*

Oil on canvas, 22 x 18 in.
Signed (at lower left): Bevan
Painted in 1916

EXHIBITED: P. & D. Colnaghi & Co., London,
1961, *Paintings by Robert Bevan 1865-1925*, [n.p.]
no. 16 // The Minories, Colchester, England, 1975,
The R. A. Bevan Collection from Boxted House,
[n.p.] no. 26

EX COLL.: the artist; to his estate, until 1987

3

4

5

3. *Burford Farm, Devon*

Oil on canvas, 25 x 30 in.
Signed (at lower right): Robert Bevan
Painted about 1918

EX COLL.: the artist; to his estate, until 1987

Burford Farm was painted during one of Bevan's
summer visits to Devon. Of all the Camden Town
painters, Bevan consistently depicted the unspoiled
agrarian countryside in his landscape paintings.
This aspect of his work is allied with a tradition of
English landscape painting extending back to
Joseph M. W. Turner and John Constable.

4. *Clayhidon*

Charcoal on paper, 13¾ x 17 in.
Signed with estate stamp (at lower left): RPB
Executed about 1917

EX COLL.: the artist; to his estate, until 1987

Bevan made his first visit to Harold B. Harrison's
country home in the Blackdown Hills, near
Clayhidon, in 1912. Harrison became Bevan's friend
and patron. Bevan continued to enjoy painting and
drawing the countryside of this region, and in 1916
he rented a cottage there. This drawing, depicting
the environs of Clayhidon, is a preparatory study
squared-up for transfer to canvas.

5. *On Luppitt Hill*

Oil on canvas, 25 x 30 in.
Signed (at lower right): Robert Bevan
Painted in 1922

EX COLL.: the artist; to his estate, until 1987

Bevan moved to the village of Luppitt, on the Devon
border, in 1920. He spent the remaining years of his
life there. High horizons and bold surface patterns
characterize many of his landscapes painted during
this late period.

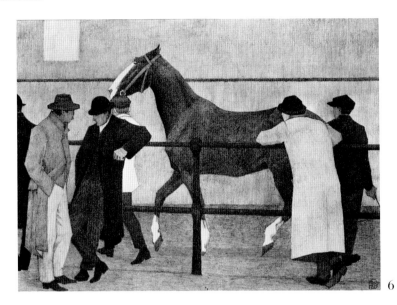

6

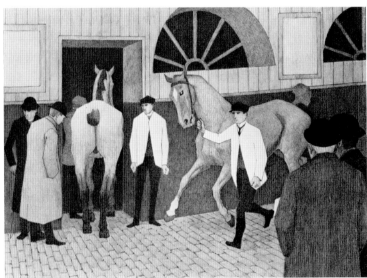

7

6. *Horse Dealer (Ward's Repository No. 1)*

Lithograph, 10⅞ x 14⅞ in.
Executed in 1919
Edition: 80

RECORDED: *cf.* R. A. Bevan, *Robert Bevan 1865-1925: A Memoir by his Son* (1965), pl. 62 // *cf.* Graham Dry, *Robert Bevan 1865-1925: Catalogue Raisonné of the Lithographs and Other Prints* (1968), [n.p.] no. 33

EX COLL.: the artist; to his estate, until 1987

Bevan's depictions of horses, landscape, and hunting scenes rank among his best work. Between 1919 and 1921, at a time when motor-driven cars were replacing horse-drawn carriages, he completed a set of lithographs based on the London horse exchange. Printed by himself, these originally met with little success. Today, they are recognized as important prints of their time.

7. *The Horse Mart (Barbican No. 1)*

Lithograph, 10⅝ x 14⅞ in.
Executed in 1920
Edition: 65

RECORDED: *cf.* Graham Dry, *Robert Bevan 1865-1925: Catalogue Raisonné of the Lithographs and Other Prints* (1968), [n.p.] no. 34

EX COLL.: the artist; to his estate, until 1987

This lithograph is related to an earlier painting, *The Horse Mart*, 1917-18 (private collection, Upperville, Virginia).

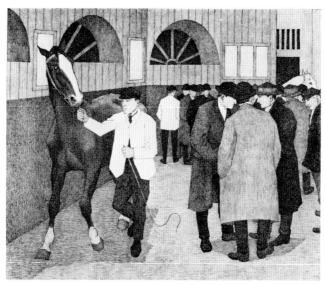

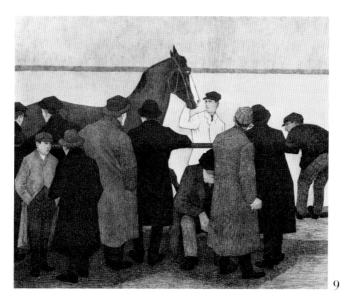

8. *Horse Dealers at the Barbican (Barbican No. 2)*

Lithograph, 11¾ x 14 in.
Executed in 1921
Edition: 70

RECORDED: *cf.* Graham Dry, *Robert Bevan 1865-1925: Catalogue Raisonné of the Lithographs and Other Prints* (1968), [n.p.] no. 35

EX COLL.: the artist; to his estate, until 1987

9. *Sale at Ward's Repository (Ward's No. 2)*

Lithograph, 12³⁄₁₆ x 14½ in.
Executed in 1921
Edition: 50

RECORDED: *cf.* Graham Dry, *Robert Bevan 1865-1925: Catalogue Raisonné of the Lithographs and Other Prints* (1868), [n.p.] no. 36

EX COLL.: the artist; to his estate, until 1987

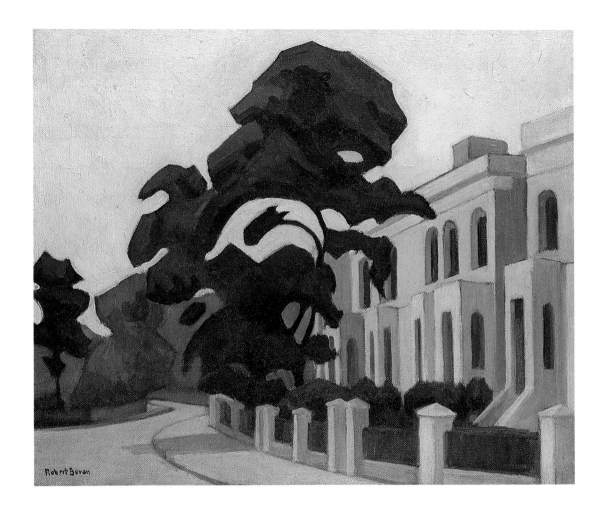

10. *King Henry's Road, Hampstead*

Oil on canvas, 18 x 22 in.
Signed (at lower left): Robert Bevan
Painted between 1920 and 1922

EX COLL.: the artist; to his estate, until 1987

Scenes of London street life were common subjects
for the Camden Town painters. Bevan concentrated
on the area around his own home at 14 Adamson
Road in Hampstead, a suburb of London just north
of Camden Town. Hampstead was more fashionable
than Camden Town, and in many of his pictures
Bevan celebrated its clean, tree-lined streets and
orderly rows of white Victorian houses.

HAROLD GILMAN (1876-1919)

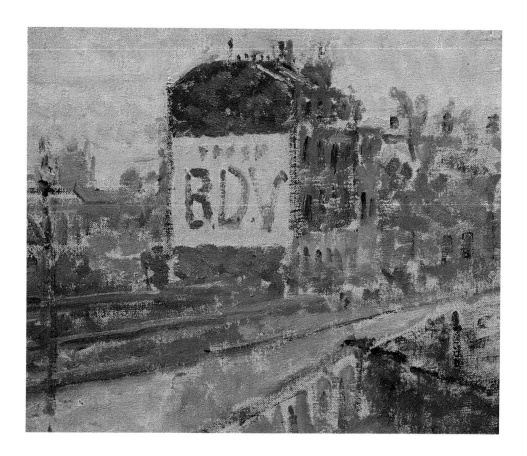

11. *Hampstead Road, London*

Oil on canvas, 10 x 12 in.
Painted about 1910-11

EXHIBITED: Lefevre Gallery, London, 1948, *Paintings and Drawings by Harold Gilman 1876-1919*, [n.p.] no. 21, dated about 1913 // Fine Art Society, London, 1976, *Camden Town Recalled*, p. 25 no. 29, as *Hampstead Road (B.D.V.)*

EX COLL.: the artist; to his son, John Gilman; to [Fine Art Society, London, in 1976]; to Dr. Terry Friedman, Leeds; to private collection, London, until 1987

Hampstead Road leads north from central London into Camden Town. At number 140 Hampstead Road, Walter Sickert set up his Rowlandson House Art School, which remained in operation from 1910 to 1914. Gilman, along with Spencer Gore, often painted in and around the school's garden. Depicted here are the terraces of the houses alongside the Rowlandson School. The school itself is shown as the second house from the end of the block. The billboard of "B.V.D." advertised a popular brand of cigarettes.

12. *Mother and Child*

Ink on paper, 9½ x 8 in.
Executed in 1915

EX COLL.: the artist; to his estate; to Mrs. Barbara
Duce; to private collection, London, until 1987

Mother and Child is a drawing of Gilman's second
wife, Sylvia Hardy, and their son John, who was
born in December 1917. This is one of several studies
of the subject which resulted in a painting, *Mother
and Child* (Auckland City Art Gallery, New
Zealand). As an example of Gilman's mature
drawing style, *Mother and Child* reflects the artist's
study of Van Gogh, in particular his bold quill ink
drawings.

13. *Portrait of Mrs. Bevan*

Oil on canvas, 24 x 20 in.
Painted about 1911

EXHIBITED: Leicester Galleries, London, 1919,
Harold Gilman: Memorial Exhibition, [n.p.] no. 38
// Arthur Tooth & Sons, London, 1934, *Harold
Gilman*, [n.p.] no. 4 // Colchester Castle Museum,
England, 1951, *Festival of Britain*, [n.p.] no. 18 //

The Minories, Colchester, England, 1975, *The R. A.
Bevan Collection from Boxted House*, [n.p.] no. 62
// Anthony d'Offay Gallery, London, 1975, *English
Paintings from the Bevan Collection: A Memorial
Exhibition for R. A. Bevan 1901-1974*, [n.p.] no. 12
illus. // Yale Center for British Art, New Haven,
Connecticut, 1980, *The Camden Town Group*, p. 21
no. 30 illus.

EX COLL.: the artist; to private collection; to the
sitter's son, R. A. Bevan, until 1974; to private
collection, England, until 1987

This is one of three portraits by Gilman of
Stanislava de Karlowska (1876-1952), a Polish-
born painter who married Robert Bevan in 1897.
With its heightened palette of violets, greens, and
light browns, it is typical of the intimate portraiture
practiced by the Camden Town artists. The informal
setting, preferred by Gilman and his associates,
includes floral wallpaper, a sturdy chest of drawers,
and a stout English teacup and saucer. Mrs. Bevan
was an original member of the London Group in
1913. Three of her own pictures are in the Tate
Gallery, London.

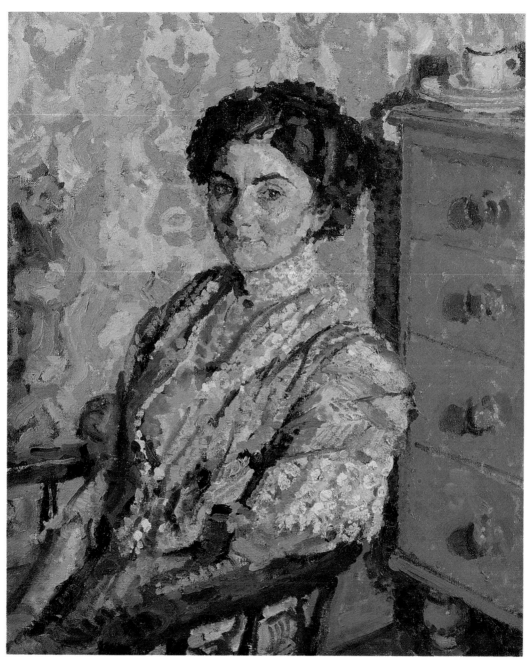

13

CHARLES GINNER (1878-1952)

14. *Timber Yard, Leeds*

Oil on canvas, 30 x 40 in.
Signed (at lower right): C. Ginner
Painted in 1915

RECORDED: Charles Ginner, "Notebooks," I (1915), p. 86

EXHIBITED: Goupil Gallery, London, 1915, *Cumberland Market Group* // Goupil Gallery, London, 1915, *The London Group* // Grosvenor Galleries, London, 1922, *Colour Exhibition* // Anthony d'Offay Gallery, London, 1975, *English Paintings from the Bevan Collection: A Memorial Exhibition for R. A. Bevan 1901-1974*, [n.p.] no. 16 illus. // The Minories, Colchester, England, 1975, *The R. A. Bevan Collection from Boxted House*, [n.p.] no. 74 // Christie's, London, 1986, *New English Art Club: Centenary Exhibition*, no. 167

EX COLL.: the artist; to R. A. Bevan, until 1974; to private collection, England, until 1987

The Yorkshire city of Leeds, a manufacturing and trade center in the mid-nineteenth century, grew and prospered during the Industrial Revolution. Beginning in 1912, the Leed's City Art Gallery, directed by the critic Frank Rutter, actively supported many of the Camden Town painters. (Rutter also owned the finished preparatory drawing for this painting.) Ginner made preliminary studies for this painting during a visit to Leeds with Harold Gilman in 1915. Two paintings, *The Timber Yard* and Gilman's *Leeds Market* (Tate Gallery, London) resulted from the artists' trip to the city.

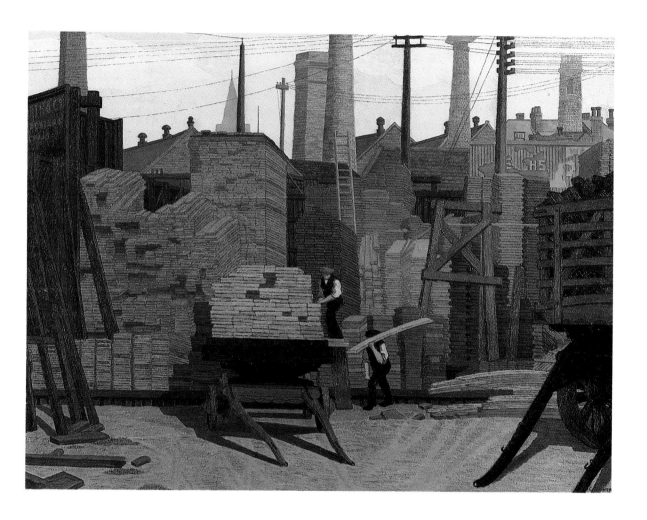

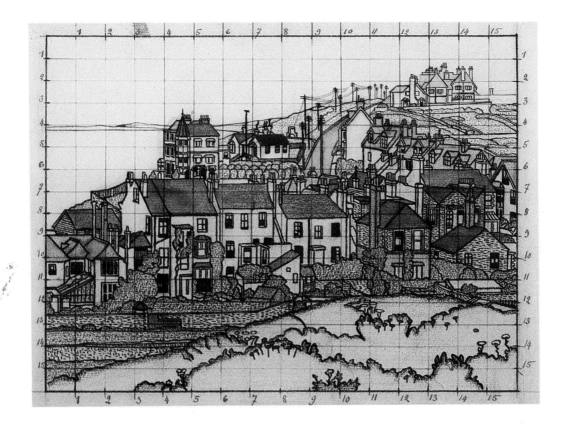

15. *Study for "Rottingdean"*

Watercolor, pastel, and ink on paper, 8 x 11 in.
Executed in 1914

RECORDED: Charles Ginner, "Notebooks," I
(1914), p. 73

EXHIBITED: Goupil Gallery, London, 1914,
Harold Gilman and Charles Ginner

EX COLL.: the artist; to Walter Taylor; to private
collection, London, until 1987

Study for "Rottingdean," a complete working
drawing for a painting of the same title, was
exhibited in The London Group exhibition at the
Goupil Gallery in 1914. In the early years of the
twentieth century the picturesque village of
"Rottingdean," inland from the Sussex coast near
Brighton, was frequented by writers and painters,
among them Rudyard Kipling, Edward Burne-
Jones, and William Nicholson. In *Study for
"Rottingdean,"* Ginner's interest shifted away from
the "olde worlde" village green and quaint
eighteenth-century houses to more modern
buildings and telegraph poles, which had begun to
appear along the Sussex coastline.

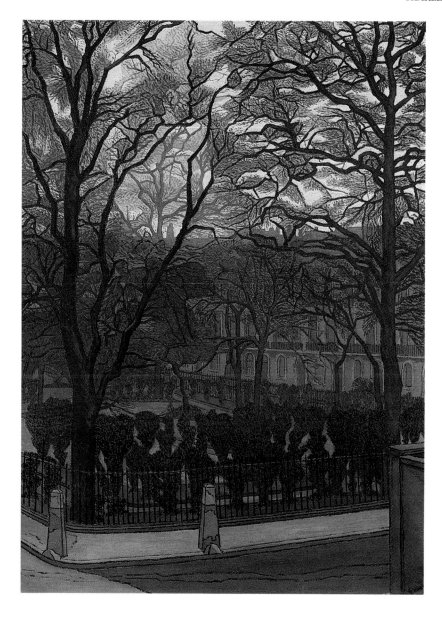

16. *A London Square*

Oil on canvas, 27 x 20 in.
Signed (at lower right): C. Ginner
Painted in 1917

RECORDED: Charles Ginner, "Notebooks," I
(1914), p. 101

EXHIBITED: Heal's Gallery, London, 1917, *The
London Group*, [n.p.] [n.n.] // The Leicester
Galleries, London, 1917

EX COLL.: the artist; to Mrs. Charles W. Harrison;
[J. Leger & Son, London, 1938]; to private
collection, England, until 1987

Of all the Camden Town artists, Ginner is best
known for his many views of London, from
Piccadilly Circus to the quieter suburbs of
Hampstead and Islington. In *A London Square*,
Ginner depicted a quiet square in either Camden
Town or Islington, characterized by its neat railings,
rows of well-kept trees, and pristine architectural
facades.

SPENCER FREDERICK GORE (1878-1914)

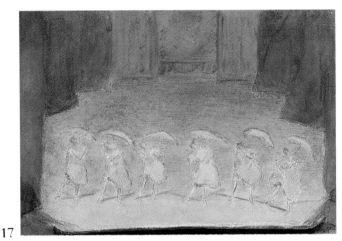

17

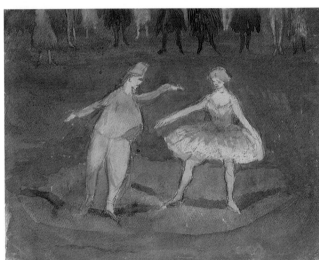

18

17. *Corps de Ballet from "Entente Cordiale"*

Watercolor on paper, 7 x 10 in.
Signed and inscribed (at lower right): S.F. Gore; (on the back): Palace Theatre
Executed in 1904

EXHIBITED: Harrow School, London, 1987, *Spencer Frederick Gore*, [n.p.] no. 23, as *Corps de Ballet with Parasols in Blue*, dated about 1903

EX COLL.: the artist; to his estate, until 1987

An amateur actor and singer, Gore shared with Walter Sickert a love of the theatre. He studied the elaborate costumes and scenery of short ballets presented alongside acts by comedians and acrobats in the big London variety theatres, such as the Empire and the Alhambra, both in Leicester Square. This watercolor depicts a corps de ballet dressed in Japanese costumes, who chased away the Russians in *Entente Cordiale*, a production performed at the Empire in 1904.

18. *Pas de Deux*

Watercolor on gray paper, 7¼ x 9¼ in.
Executed about 1904

EX COLL.: the artist; to his estate, until 1987

19. *The Mimram, Panshanger Park*

Oil on canvas, 20 x 30 in.

Painted in 1908

EXHIBITED: Arts Council of Great Britain,
London, 1955, *Spencer Frederick Gore 1878-1914*,
p. 11 no. 16 // Redfern Gallery, London, 1962,
Spencer Gore and Frederick Gore, [n.p.] no. 31

EX COLL.: the artist; to his estate, until 1987

The River Mimram, near Gore's mother's house in
Hertingfordbury, runs through the Panshanger
Estate. Gore spent several weeks there in the
summer of 1908 painting landscapes. In addition to
The Mimram, Gore painted *The Pool, Panshanger
Park* (Art Gallery of New South Wales, Sydney,
Australia), *The Pool* (Southampton Art Gallery,
England), and *The Mimram* (Reading Museum and
Art Gallery, London) during this period.

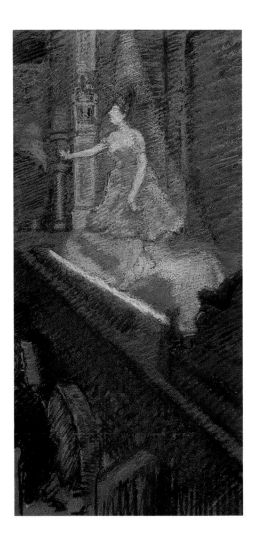

20. *A Music-Hall Turn*

Pastel on gray paper, 14½ x 8¼ in.
Inscribed (on the back): Pastel by S. F. Gore
Executed in 1909
EX COLL.: the artist; to his estate, until 1987

Walter Sickert's music hall paintings encouraged
Gore's own involvement with this milieu, and
theatre interiors are a central aspect of his work.

Whereas Sickert preferred the plush gilt of the
smaller halls, Gore sought out the exotic splendor
and monumental scale of theatres such as the
Alhambra. This pastel study, in contrast to Gore's
more spontaneous sketches of the theatre, is related
to the highly-finished *Inez and Taki* (The Museum
of Modern Art, New York).

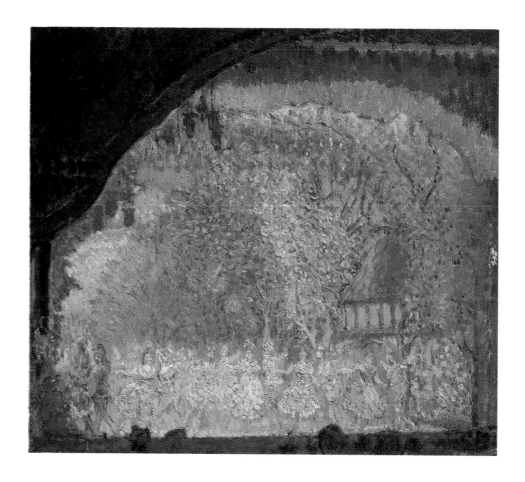

21. *Les Cloches de Corneville*

Oil on canvas, 16 x 18 in.
Painted in 1909

EX COLL.: the artist; to his estate, until 1987

Originally produced in 1907, the ballet *Les Cloches de Corneville* opened at the Alhambra during the 1909 season. For this production, the leading ballerina was Britta Petersen, the Danish dancer who also appeared in *Our Flag*, a ballet from which *Rule Brittania* (cat. no. 22) was adapted. Among the many memorable scenes in *Les Cloches de Corneville*, Gore selected the amorous "Kissing Waltz" to depict in this painting.

22. *Rule Brittania*

Oil on canvas, 30 x 25 in.
Signed and inscribed (on the back stretcher):
Spencer F. Gore Rule Brittania/19 Fitzroy Street
Painted in 1910

RECORDED: John Woodeson, "Spencer Gore," in *The Connoisseur* (Mar. 1974), p. 175 no. 1 illus., as *The Brittania Ballet at the Alhambra* // Simon Watney, *English Post-Impressionism* (1980), p. 37 pl. 19, as *The Brittania Ballet, The Alhambra/Our Flag* // Claudio Zambianchi, "Appunti su Spencer Frederick Gore e la pittura inglese fra il 1908 e il 1910," in *Storia dell'Arte*, No. 58 (1986), pp. 282-83 no. 7 illus., as *Brittania Ballet*

EXHIBITED: New English Art Club, London, 1910, *Summer Exhibition*, no. 204 // Chenil Gallery, London, 1911, *Spencer Gore*, no. 3 // Manchester City Art Gallery, England, 1911, *Contemporary Art Society Exhibition*, no. 57 // Goupil Gallery, London, 1913, *Contemporary Art Society Exhibition*, no. 130 // Whitechapel Art Gallery, London, 1914, *Twentieth Century Art*, no. 407 // Southampton Art Gallery, England, 1951, *The Camden Town Group*, no. 60, dated about 1910 // Redfern Gallery, London, 1962, *Spencer Gore and Frederick Gore*, [n.p.] no. 27, as *The Brittania Ballet, The Alhambra, 1907* // The Minories, Colchester, Ashmolean Museum, Oxford, and Graves Art Gallery, Sheffield, England, 1970, *Spencer Gore 1878-1914*, [n.p.] no. 28, as *The Brittania Ballet, The Alhambra* // Royal Academy of Arts, London, 1979-80, *Post-Impressionism*, p. 193 no. 300 illus. // Anthony d'Offay Gallery, London, 1983, *Spencer Frederick Gore*, p. 36 no. 7 illus. // Harrow School, London, 1987, *Spencer Frederick Gore*, [n.p.] no. 20

EX COLL.: the artist; to his estate, until 1987

Our Flag, a patriotic ballet, opened at the Alhambra on December 20, 1909, and ran for a year. From a sixpenny seat, or sometimes a box, Gore made studies of this and other productions which formed the basis of much of his work between 1906 and 1912. In this picture, Britta Petersen performs the popular dance *Rule Brittania*.

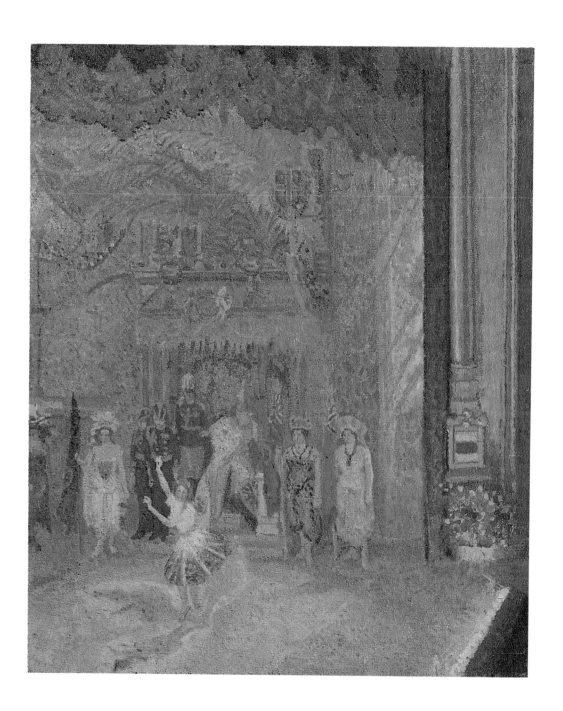

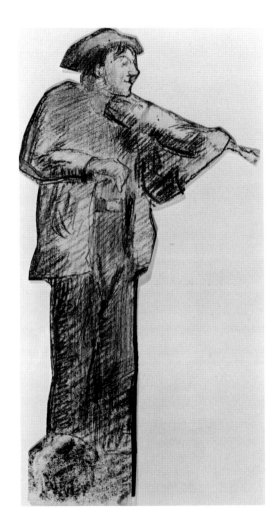

23. *Study for "Rinaldo, The Mad Violinist"*

Pastel on paper, 8 x 4⅛ in.
Executed about 1910-11

EXHIBITED: Yale Center for British Art, New Haven, Connecticut, 1980, *The Camden Town Group*, p. 45 no. 61c

This is one of four studies that Gore made for the painting. In each one he investigated a slightly different pose and attitude. In this particular drawing the figure has been cut out by the artist, who originally used it as a guide for establishing the exact position of the violinist within the final painting.

24. *Rinaldo, The Mad Violinist*

Oil on canvas, 16⅛ x 12⅛ in.
Estate stamp (at lower right): S.F. Gore

RECORDED: Wendy Baron, *The Camden Town Group* (1979), pp. 10, 31, 117 pl. 5, 240

EXHIBITED: Carfax Gallery, London, 1916, *Spencer Frederick Gore: Memorial Exhibition*, no. 32, as *Rinaldo*, dated 1911 // Arts Council of Great Britain, London, 1955, *Spencer Frederick Gore*, p. 12 no. 27, as *Rinaldo at the Alhambra* // Redfern Gallery, London, 1955, *Spencer Gore and Frederick Gore*, [n.p.] no. 81, as *Rinaldo: The Mad Violinist at the Alhambra* // Anthony d'Offay Gallery, London, 1974, *Spencer Frederick Gore*, p. 37 no. 16 // Fine Art Society, London, 1976, *Camden Town Recalled*, p. 32 no. 68 // Yale Center for British Art, New Haven, Connecticut, 1980, *The Camden Town Group*, p. 44 no. 60 illus., as *Rinaldo: The Mad Violinist at the Alhambra*

EX COLL.: the artist; to his estate, until 1977; to private collection, London, until 1987

When this painting was first exhibited, it was titled simply *Rinaldo*. Later on, its interior was identified as being the Alhambra Theatre, but its lack of ostentatious ornamentation is more reminiscent of the New Bedford Theatre. Compositionally, *Rinaldo* recalls similar theatre interiors by Sickert, who also frequented the New Bedford Theatre.

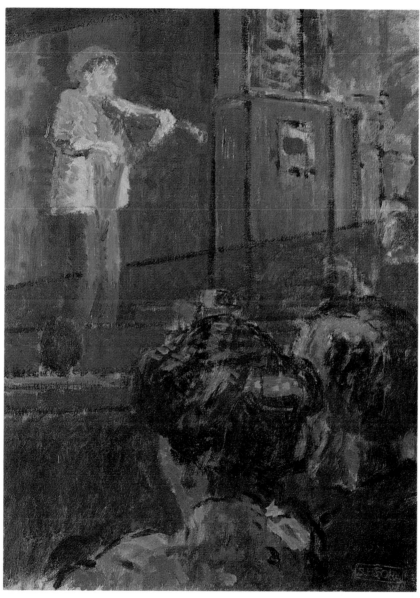

24

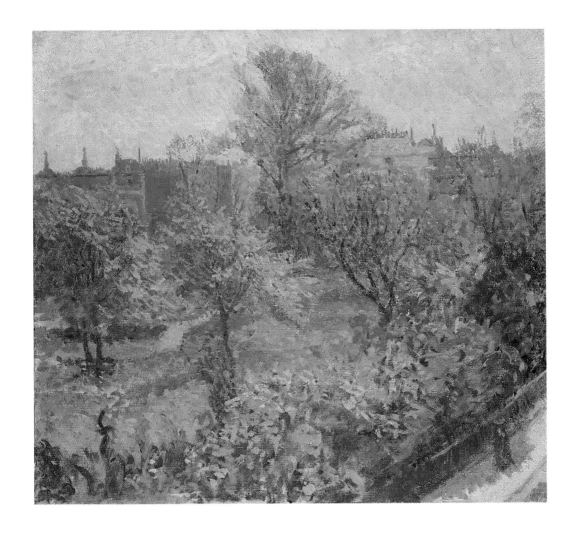

25. *View from 31 Mornington Crescent*

Oil on canvas, 15½ x 17½ in.
Painted about 1911

EXHIBITED: Leicester Galleries, London, 1928,
Exhibition of Paintings by Spencer F. Gore, [n.p.]
[n.n.]

Beginning in 1909, Gore rented a room at 31
Mornington Crescent, which looked out over trees
and gardens towards Hampstead Road in Camden
Town. This is one of a series of views that Gore
painted from the rooms he rented as his studio.

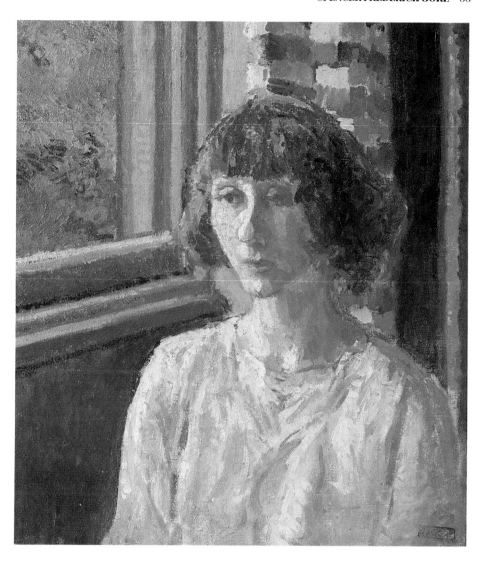

26. *Portrait of Mrs. S. F. Gore at 31 Mornington Crescent*

Oil on canvas, 20 x 18 in.
Painted in 1911
Estate stamp (at lower right): S. F. Gore

EXHIBITED: Arts Council of Great Britain, London, 1955, *Spencer Frederick Gore*, p. 12 no. 26 // Redfern Gallery, London, 1962, *Spencer Gore and Frederick Gore*, [n.p.] no. 56, as *Portrait of Mrs. Spencer Gore* // Harrow School, London, 1987, *Spencer Frederick Gore*, [n.p.] no. 32

EX COLL.: the artist; to his estate, until 1987

In January 1912, Gore married Mollie Kerr, whom he had painted on several occasions before their marriage. This particular portrait, perhaps the most intimate of the series, shows Mollie at the window of Gore's Mornington Crescent room.

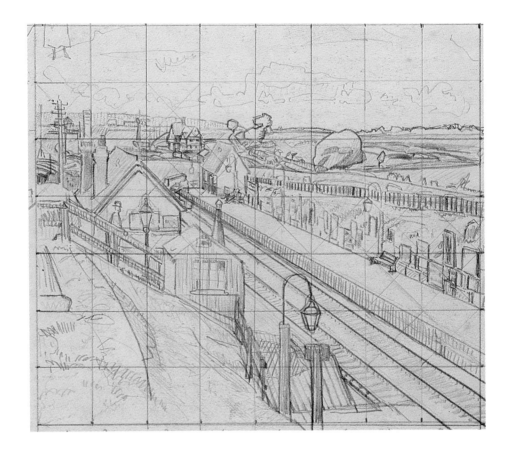

27. *Study for "Letchworth Station"*

Colored crayon and pencil on paper, 9 x 12 in.
Executed about 1912

EXHIBITED: Yale Center for British Art, New
Haven, Connecticut, 1980, *The Camden Town
Group*, p. 50 no. 67 illus.

EX COLL.: the artist; to his estate, until 1987

This drawing is related to several studies for
Letchworth Station (National Railway Museum,
York, England), a painting that Roger Fry included
in his second Post-Impressionist exhibition at the
Grafton Galleries in 1912. The drawing is squared-
up for transfer to canvas. The subject of a suburban
railway station demonstrates Gore's willingness to
explore a variety of subjects, from modern villas,
music halls, and aerodromes to seaside piers at
Brighton.

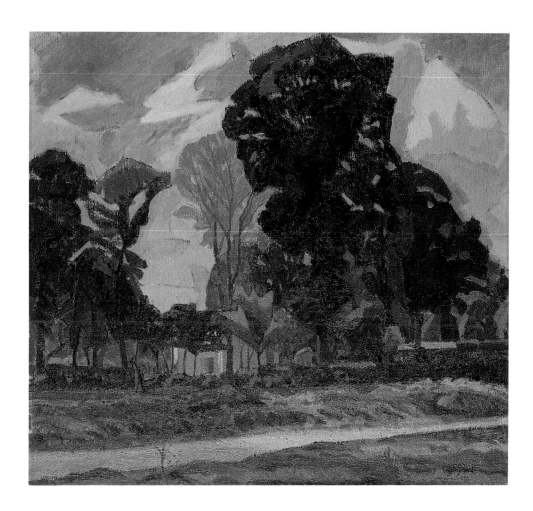

28. *Crofts Lane, Letchworth*

Oil on canvas, 24 x 26 in.
Painted in 1912
Signed (at lower right): S. F. Gore

EXHIBITED: Leicester Galleries, London, 1914, *Spencer Gore*, no. 94 // Goupil Gallery, London, 1914, *First London Group Exhibition*, no. 94 // Carfax Gallery, London, 1916, *Paintings by the Late Spencer F. Gore*, no. 28 // Leicester Galleries, London, 1928, *Exhibition of Paintings by Spencer F. Gore*, no. 71 // Southampton Art Gallery, England, 1951, *The Camden Town Group*, no. 64 // Arts Council of Great Britain, London, 1955, *Spencer Frederick Gore*, p. 13 no. 36 // Redfern Gallery, London, 1962, *Spencer Gore and Frederick Gore*, [n.p.] no. 62, as *Crofts Lane* // The Minories, Colchester, Ashmolean Museum, Oxford, and Graves Art Gallery, Sheffield, England, 1970, *Spencer Gore 1878-1914*, [n.p.] no. 48 illus. // Anthony d'Offay Gallery, London, 1983, *Spencer Frederick Gore 1878-1914*, p. 37 no. 24 illus. // Royal Academy of Arts, London, 1987, *British Art in the 20th Century*, p. 111 no. 9 illus. // Harrow School, London, 1987, *Spencer Frederick Gore*, [n.p.] no. 21

EX COLL.: the artist; to his estate, until 1987

In the latter half of 1912, Gore borrowed Harold Gilman's house in Letchworth, Hertfordshire, near London. From here he painted views of Letchworth station and the outlying countryside. *Crofts Lane* reflects Gore's desire to simplify his compositions with bold passages of flat color.

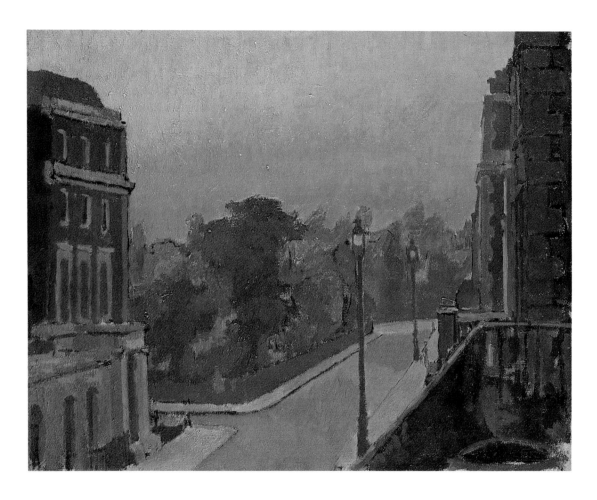

29. *A London Sunset, Harrington Square from 2 Houghton Place*

Oil on canvas, 16 x 20 in.
Estate stamp (at lower right): S.F. Gore
Painted in 1913

EXHIBITED: Carfax Gallery, London, 1918, *Spencer Frederick Gore*, no. 26 // Arts Council of Great Britain, London, 1953, *The Camden Town Group*, [n.p.] no. 32 // Arts Council of Great Britain, London, 1955, *Spencer Frederick Gore*, p. 13 no. 39 // Redfern Gallery, London, 1962, *Spencer Gore and Frederick Gore*, [n.p.] no. 65, as *Sunset, Harrington Square* // The Minories, Colchester, Ashmolean Museum, Oxford, and Graves Art Gallery, Sheffield, England, 1970, *Spencer Gore 1878-1914*, [n.p.] no. 58, as *Sunset, Harrington Square* // Anthony d'Offay Gallery, London, 1983, *Spencer Frederick Gore*, p. 34 no. 30 illus.

EX COLL.: the artist; to his estate, until 1987

Gore painted this view from his house at 2 Houghton Place during the summer of 1913, before he moved to the rural environs of Richmond, England.

30. *The Tennis Match: Design for a Mural in the Cabaret Theatre Club*

Watercolor, ink, and pencil on paper, 12 x 10 in. Executed in 1913

EXHIBITED: Anthony d'Offay Gallery, London, 1984, *The Omega Workshops: Alliance and Enmity in English Art 1911-1920*, [n.p.] no. 41f

EX COLL.: the artist; to his estate, until 1987

The Cabaret Theatre Club, London's first avant-garde night club, was opened at 9 Heddon Street on June 26, 1912. It was run by Frida Strindberg, the former wife of the Swedish playwright August Strindberg. She envisioned the club as a center for experimental cabaret and performance, and she commissioned Wyndham Lewis, Charles Ginner, and Spencer Gore to execute interior decorations. Gore oversaw the entire project, for which he also painted two monumental murals. Outdoor sports were popular subjects among vanguard English artists at the time, and Gore depicted a tennis match, a subject he portrayed some years earlier in a painting titled *Tennis, Hertingfordbury* (private collection, England).

WALTER RICHARD SICKERT (1860-1942)

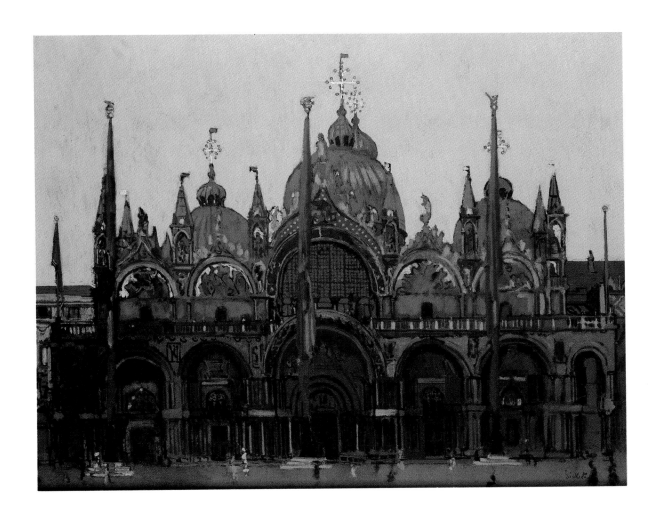

31. *The Facade of St. Mark's, Venice*

Oil on canvas, 45½ x 60½ in.
Signed (at lower right): Sickert
Painted about 1896-97

RECORDED: Wendy Baron, *Sickert* (1973), p. 316
no. 100/2

EXHIBITED: Temple Newsam House, Leeds,
England, 1942, *Walter Sickert Retrospective*, [n.p.]
no. 132

EX COLL.: the artist; to J. E. Crawford Flitch; on
loan to Leeds City Art Gallery, 1925-87

Sickert made his first visit to Venice in 1896, and
thereafter he made frequent visits, sometimes for
several months at a time, until 1904. During his
earlier stays, he concentrated on the architecture
and the canals; later he painted local models and
began a series of figures in interiors that culminated
in his Camden Town paintings, which he began in
1906. In this crepuscular picture, Sickert's debt to
Whistler is still evident, but he is beginning to
integrate a more expressive palette.

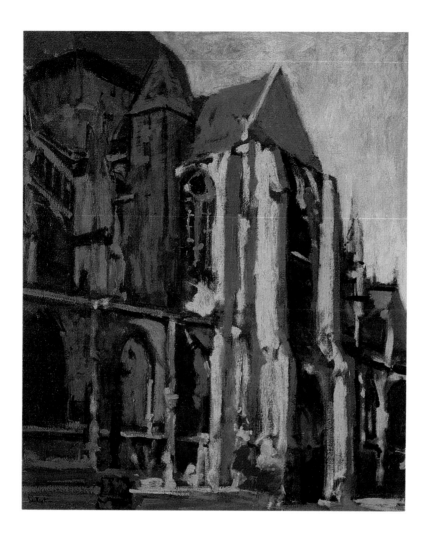

32. *South Facade of St. Jacques*

Oil on canvas, 21½ x 17¾ in.
Signed (at lower left): Sickert
Painted about 1900

RECORDED: Wendy Baron, *Sickert* (1973), p. 321
no. 116 pl. 82

EX COLL.: Stuart G. Bennett, Ontario, Canada

Sickert knew the ancient French fishing port and
summer resort of Dieppe, on the Normandy coast,
from his adolescence. He had spent many summers
there until the early 1920's and had resided there
more or less continuously from 1898 until his return
to London in 1905. He drew and painted every
aspect of the town (a popular retreat for painters
who included Camille Pissarro, Jacques-Emile
Blanche, and James McNeill Whistler)—its streets,
arcades, shops and cafes, busy port, and market
squares. The Gothic church of St. Jacques, with its
towering dome rising above the huddled rooftops of
the town, dominates many of these paintings. In this
work, Sickert's viewpoint is from the south.

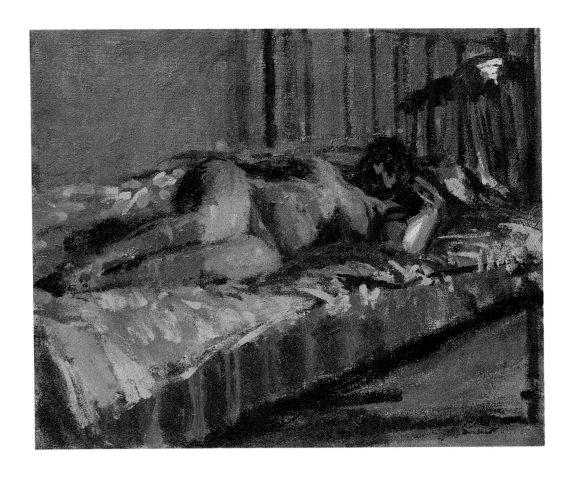

33. *Nude Reclining on a Bed*

Oil on canvas, 17½ x 21½ in.
Signed (at lower right): Sickert
Painted about 1904-05

RECORDED: Wendy Baron, *Sickert* (1973), pp. 84,
336 no. 202, as *Nude on a Bed*

EXHIBITED: Art Council of Great Britain,
Edinburgh, Scotland, 1953, *Sickert*, [n.p.] no. 23 //
Thos. Agnew and Sons, London, 1960, *Sickert:
Centenary Exhibition of Pictures from Private
Collections*, [n.p.] no. 45 // Thos. Agnew and Sons,
London, 1983, *The Realist Tradition*, p. 7 no. 4

EX COLL.: the artist; to M. Geoffrey, Paris, France;
to Howard Bliss; to F. J. Lyons; to [Thos. Agnew and
Sons, London]; to private collection, London, until
1987

Nude Reclining on a Bed was painted in Dieppe
shortly before Sickert returned to England. The
picture is among the earliest examples of a theme
that continued to preoccupy the artist. The model in
this picture is Sickert's French mistress, Mme.
Viflain, who also appears, similarly posed, in two
versions of his *Le Lit de cuivre* (Royal Albert
Memorial Museum, Exeter, and private collection,
London). The public's initial reaction to these
intimate scenes was one of moral indignation.
Today, however, they are recognized as some of
Sickert's most innovative works.

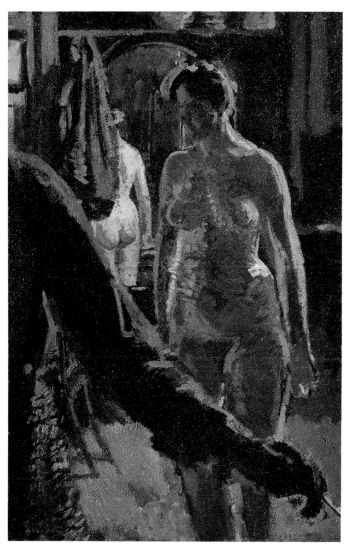

34. *The Studio*

Oil on canvas, 29½ x 19¾ in.
Signed (at lower left): Sickert
Painted in 1907

RECORDED: Wendy Dimson, "Four Sickert
Exhibitions," in *The Burlington Magazine*, No. 102
(Oct. 1960), pp. 440, 442, fig. 31 // Lillian Browse,
Sickert (1960), p. 78 pl. 74 // Wendy Baron, *Sickert*
(1973), no. 297 pl. 206

EXHIBITED: Eldar Gallery, London, 1919, *Sickert,
Paintings and Drawings*, [n.p.] no. 41, as *The
Studio* // Thomas Agnew & Sons, London, 1960,
*Sickert: Centenary Exhibition of Pictures from
Private Collections*, [n.p.] no. 61 // Arts Council of
Great Britain, London, 1960, *Sickert, Paintings and
Drawings*, [n.p.] no. 126 // Royal Pavilion,
Brighton, England, 1962, *Sickert*, [n.p.] no. 82 //
Royal Academy of Arts, London, 1987, *British Art in
the 20th Century*, p. 104 no. 3 illus., as *The Studio,
the Painting of a Nude*, dated about 1911-12

EX COLL.: the artist; to Morton Sands, and thence
by descent in the family, until 1987

Working out of his Camden Town studio, Sickert
innovated a genre of painted interiors with nudes.
Characteristic of this series of pictures, *The Studio* is
noteworthy for its compositional complexity and
levels of perception. While Sickert continually
advised his students and colleagues (Harold
Gilman, Robert Bevan, and Charles Ginner) to paint
nudes in domestic interiors, he was not against
painting this subject without narrative or symbolic
overtones. A straightforward presentation with an
evocative touch of mystery, *The Studio*
demonstrates Sickert's consistent experimentation
with this genre.

35. *L'Eldorado*

Oil on canvas, 20 x 23⅞ in.
Painted about 1905

RECORDED: *The Studio,* C (Nov. 1930), p. 324
illus. // Wendy Baron, *Sickert* (1973), p. 342, below
no. 235

EXHIBITED: Glasgow Institute of Fine Arts,
Scotland, 1949, *Sickert*

EX COLL.: Mrs. M. Clifton; J. C. King; Robert
Haines

The Eldorado was one of the music halls that Sickert
frequented while he was living in Paris between
1906 and 1907. He depicted the plush interior of the
theatre from many viewpoints, varying his
presentation and distance from center stage. This
kind of theatrical genre, with members of the
audience positioned in the foreground and oriented
toward the stage, recalls similar interiors by Henri
de Toulouse-Lautrec and Edgar Degas.

36. *Noctes Ambrosianae*

Etching, 8⅝ x 10 in.
Signed and inscribed (in lower right margin):
No. 32 Limited to 50 W. Sickert; in the plate (at
lower right): Sickert; in the plate (at lower center):
Noctes Ambrosianae
Executed in 1906

RECORDED: *cf.* Aimee Troyen, *Walter Sickert as
Printmaker* (1979), pp. 32-33 illus.

On his return to England in 1906, after spending
several years in Dieppe and Venice, Sickert began to
make studies for *Noctes Ambrosianae* (Nottingham
Castle Museum, England), one of his greatest music
hall paintings. Night after night, with sketchbook in
hand, he frequented the Middlesex Music Hall, on
Drury Lane, to observe and record the many
nuances of this setting. In addition to the painting,
Sickert made a number of drawings of the same
theme, as well as this etching, which is considered to
be his finest work in the medium.

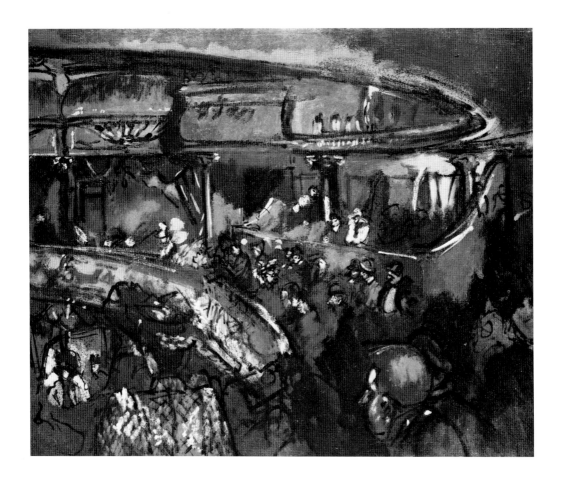

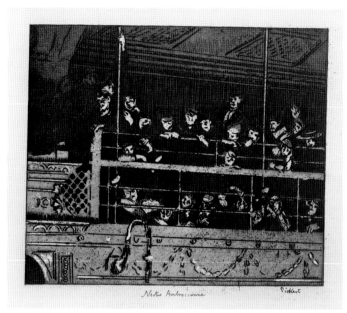

36

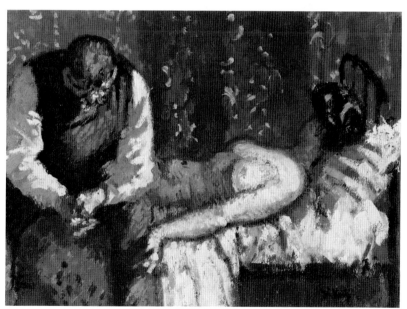

37

37. *The Camden Town Murder or What Shall We Do for the Rent?*

Oil on canvas, 10 x 14 in.
Signed (at lower right): Sickert
Painted about 1908

RECORDED: Lillian Browse, *Sickert* (1943), p. 28 illus. // Lillian Browse, *Sickert* (1960), p. 62 illus. // Wendy Baron, *Sickert* (1973), p. 348 no. 269 illus.

Lent by Yale Center for British Art, New Haven, Connecticut

Inspired by the grisly murder of a Camden Town prostitute named Emily Dimmock in September 1907, *The Camden Town Murder* is one of Sickert's most notorious subjects. Sickert is said to have used as his model the man who was charged but later acquitted for the murder. In his interpretation he focused on the moment before the crime. The picture's alternative title not only refers to a popular refrain of the music halls, but is also intended as a grim reminder of the working man's plight in Edwardian England.

38. *Sunday Afternoon*

Oil on canvas, 14¾ x 13 in.
Painted about 1915
Signed (at lower left): Sickert

RECORDED: Wendy Baron, *Sickert* (1973), p. 356

EX COLL.: the artist; to the Hon. Earl and
Countess Jowitt; to private collection, London, until
1987

39. *The London Music Hall, Shoreditch*

Pencil on paper, 14¾ x 7¼ in.
Signed and inscribed (at lower right): Sickert/The
London Shoreditch
Executed about 1918

EXHIBITED: Davis and Langdale Company, New
York, 1984, *British Drawings and Watercolors
1889-1947*, [n.p.] no. 35 illus.

EX COLL.: the artist; to Sir Hugh Walpole; to
[Leicester Galleries, London, in 1945]; to Ronald
Tree; to [Spink & Son, Ltd., in 1982]; to private
collection, London, until 1987

During the 1880's Sickert began to depict music hall
performers and audiences. He returned to the theme
on many occasions until the early 1920's. This
finished pencil drawing is related to a series of
paintings and works on paper that depict The
London Music Hall, Shoreditch. These are some of
the last theatre interiors that Sickert painted and
they represent a culmination of his interest in this
subject. The London Music Hall in Shoreditch was a
leading theatre in the East-End of London. It
opened in 1893 and remained in operation until the
1930's. Sickert preferred the more intimate Cockney
atmosphere of suburban theatres, as seen in *Noctes
Ambrosianae* (cat. no. 36), to the plush palaces of
central London.

40. *Degas at New Orleans*

Ink, gouache, crayon, and pencil on gray paper,
15½ x 13⅛ in.

Executed about 1913-14

RECORDED: Wendy Baron, *Sickert* (1973), p. 397
no. 354/2

EXHIBITED: Carfax Gallery, London, 1914, *Walter
Richard Sickert*, no. 8, as *The Artist's Home in New
Orleans* // Davis and Langdale Company, New
York, 1984, *British Drawings and Watercolors
1889-1947*, [n.p.] no. 36

EX COLL.: the artist; to [Arthur Tooth and Sons,
London]; to Lord Cottesloe; to private collection,
London, until 1987

Sickert and Edgar Degas met in Dieppe in 1885.
From then on the French artist had a strong
influence on Sickert's work, which previously had
been more indebted to Whistler's tonal harmonies.
In 1873, Degas made a sojourn to New Orleans,
Louisiana, to visit his family there. Sickert executed
this drawing as an imaginary recreation of Degas'
American trip.

The Vorticists

Vorticism was England's most radical contribution to early twentieth-century art. It set out to banish the last remnants of Victorian aesthetics in English art through a short-lived association which brought together the most innovative British artists of the period. What began as a promising modern movement, however, was terminated early on by the First World War. Artists were scattered or killed, their work dispersed, and, in many cases, destroyed, and the movement, as a whole, eventually dissolved.

Vorticist work is characterized by dynamic composition, crisp linear precision, and bold color. Its pictorial forms were inspired by the world of machines and industry. The philosopher and critic T. E. Hulme had advocated a new art grounded "not so much in the simple geometric forms found in archaic art, but in the more complicated ones associated in our minds with the idea of machinery." And in the second issue of *BLAST*, the Vorticist journal, Wyndham Lewis wrote: "A machine is in greater or less degree, a living thing. Its lines and masses imply force and action...." The American expatriate poet Ezra Pound, the first writer to introduce the word "vortex" (hence Vorticism) to describe aspects of the group, became its critical supporter and chronicler. Pound wrote: "The vortex is the point of maximum energy...." And Lewis later commented: "The Vorticist is at his maximum point of energy when stillest."

Lewis's statement seems paradoxical when considered with Pound's observation, because all the Vorticists, young and energetic, embraced the rapid changes they observed around them. "I look upon *Nature*," wrote David Bomberg in 1914, "while I live in a *steel city*: Where decoration happens, it is accidental. My object is the *construction of Pure Form*. I reject everything in painting that is not Pure Form. I hate the colours of the East, the Modern Medievalist, and the Fat Man of the Renaissance." The Vorticists depicted the mechanistic world of the city. Their impressions were frequently explosive and chaotic. The aggressive overtones inherent in their work should be viewed in relation to their European counterpart Futurism, and the ominous approach of the War.

Wyndham Lewis was actively involved in various avant-garde groups from 1910 to 1915. A writer, artist, and political activist, Lewis was a committed modernist. He was sophisticated, cosmopolitan, and emphatic in his anti-Victorian sentiments and denunciation of genteel English culture. With his ability to organize and to write, Lewis was inextricably linked with Vorticism. He not only maintained relations with other modernists of his generation—Ezra Pound, James Joyce, T. S. Eliot, and the Italian Futurists Filippo Marinetti and Gino Severini—but gathered around him a group of English painters and sculptors that included Henri Gaudier-Brzeska, Lawrence Atkinson, William Roberts, and Edward Wadsworth.

From the beginning, the Vorticist movement was compromised by internal politics. Atkinson, for example, signed the Vorticist manifesto (published in the first issue of *BLAST* in 1914) only to be one of the artists merely "invited" to show with the group in their only London exhibition at the Doré Galleries a year later. In spite of such selective favoritism, a Vorticist sensibility developed around Lewis, Wadsworth, and Roberts. All three artists exhibited together early in 1917 in the second and last Vorticist exhibition at the Penguin Club in New York City, an exhibition encouraged by the American collector John Quinn, who had always maintained a keen interest in the group's activities.

Some of the artists most closely associated with Vorticism never in fact signed its manifesto. Jacob Epstein, for example, was an American who became a British citizen in 1907. His illustrative contributions to *BLAST*, coupled with a small but significant body of work produced in the years preceding World War I, made him one of the most radical sculptors in England. Perhaps the most inventive of all the Vorticists, however, was the painter David Bomberg. Bomberg grew up in London's poor East End. Early on, while he was still a student at the Slade School of Art, he developed a series of highly original abstract works. Although he never considered himself a Vorticist per se, he did participate

as an "invited" artist in their exhibition at the Doré Galleries. Today, he is among the best known artists associated with the group.

During the early decades of the twentieth century, certain English artists produced art that vied with anything being done in Europe or America. In its intellectual rigor and visual dynamism, Vorticism attracted the attention of critics and a growing public. Their objectives were aesthetic as well as political; they set out to affect social change through their art and writings. A constructive reappraisal of the Vorticist's achievements has lead to the organization and the publication of major exhibition surveys and monographs in recent years.

LAWRENCE ATKINSON (1873-1931)

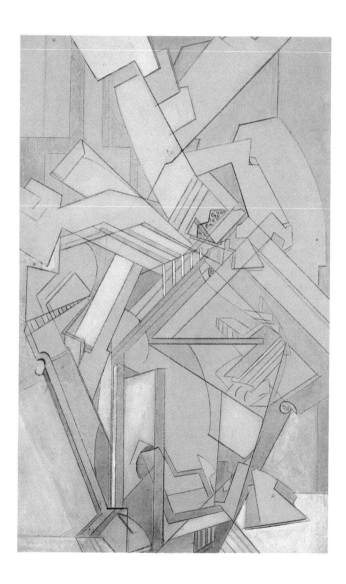

41. *Abstract Composition*

Ink, crayon, and watercolor on paper, 13¼ x 8⅜ in.
Executed between 1914 and 1916

RECORDED: Richard Cork, *Vorticism and Abstract
Art in the First Machine Age* (1976), p. 412 illus.

EXHIBITED: Anthony d'Offay Gallery, London,
1969, *Abstract Art in England 1913-1915*, p. 42
no. 2 illus. // Hayward Gallery, London, 1974,
Vorticism and its Allies, p. 91 no. 384 // Palazzo
Reale, Milan, Italy, 1979-80, *Origini
dell'Astrattismo*, [n.p.] no. 405 illus. // Yale Center

for British Art, New Haven, Connecticut, 1983,
Blast: The British Answer to Futurism, [n.p.] no. 6

EX COLL.: [Piccadilly Gallery, London, in 1965];
to private collection, London, until 1987

A musician and a poet as well as a painter and a
sculptor, Atkinson was a Renaissance man. Only a
handful of his works, however, have survived. The
drawings in this exhibition suggest Atkinson's
lyrical contributions to Vorticism.

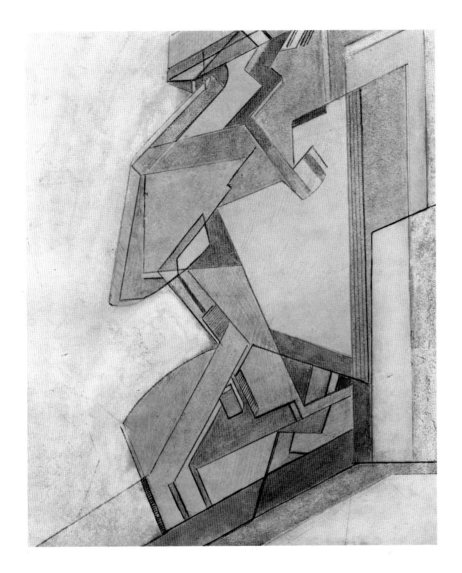

42. *Vorticist Figure*

Pencil and watercolor on paper, 10⅜ x 8¾ in.
Executed between 1914 and 1916

RECORDED: Richard Cork, *Vorticism and Abstract
Art in the First Machine Age* (1976), p. 157 illus.

EXHIBITED: Hayward Gallery, London, 1974,
Vorticism and its Allies, p. 91 no. 383 // Davis and
Long Company, New York, 1977, *Vorticism and
Abstract Art in the First Machine Age*, [n.p.] no. 3 //
Anthony d'Offay Gallery, London, 1982, *British
Drawings and Watercolours: 1890-1940*, [n.p.]
no. 3 // Anthony d'Offay Gallery, London, 1986,
*Important English Drawings Relating to Cubism
and Vorticism*, [n.p.] no. 1

EX COLL.: private collection, London, until 1974;
to private collection, London, until 1987

DAVID BOMBERG (1890-1957)

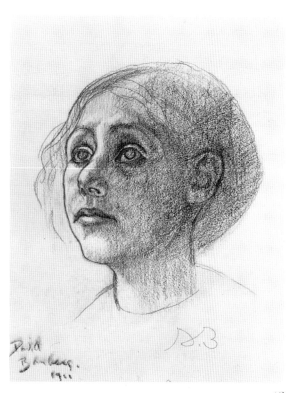

43. *Head of a Girl*

Charcoal on paper, 10½ x 8¼ in.
Signed and dated (at lower left): David/
Bomberg/1911

RECORDED: Richard Cork, *David Bomberg*
(1987), p. 19 no. 17 illus.

EX COLL.: the artist; to his estate, until 1980; to
private collection, London, until 1987

This drawing was executed while Bomberg was a
student at the Slade School of Art, London.

44. *Figure Composition*

Ink and conte crayon on paper, 7¾ x 10 in.
Executed about 1913

EX COLL.: the artist; to his estate, until 1973; to
private collection, London, until 1987

43

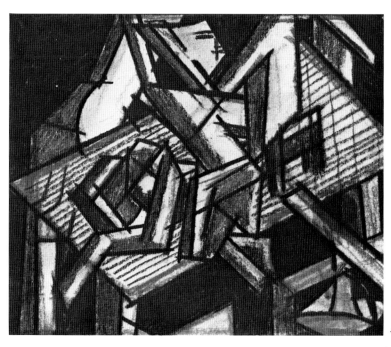

44

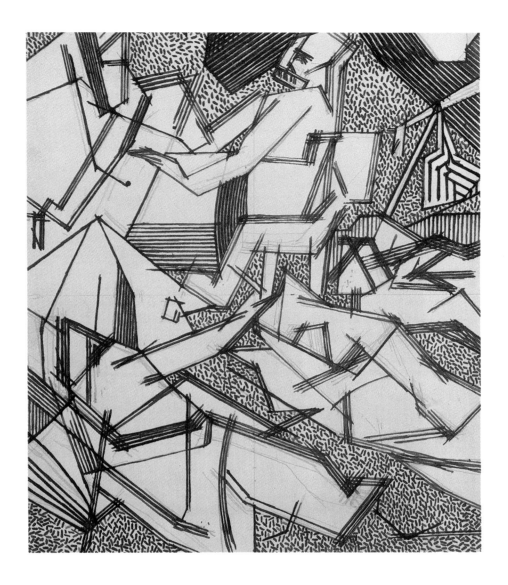

45. *Cubist Composition*

Ink and pencil on paper, 11 x 10 in.
Executed in 1913

RECORDED: Richard Cork, *Vorticism and Abstract Art in the First Machine Age* (1976), p. 79 illus. // Richard Cork, *David Bomberg* (1987), p. 58 no. 69 illus.

EXHIBITED: Fischer Fine Art, London, 1973, *Bomberg*, [n.p.] no. 40, as cover // Hayward Gallery, London, 1974, *Vorticism and its Allies*, p. 37 no. 29 // Davis and Long Company, New York, 1977, *Vorticism and Abstract Art in the First Machine Age* [n.p.] no. 5 // Anthony d'Offay Gallery, London, 1986, *Important English Drawings Relating to Cubism and Vorticism*, [n.p.] no. 4

EX COLL.: the artist; to his estate, until 1973; to private collection, London, until 1987

In 1913, after completing his studies at the Slade School, Bomberg was employed briefly at the Omega Workshops and exhibited work in the "Cubist Room" at the *Camden Town Group and Others* exhibition at the Brighton Public Art Gallery. Both of these *Cubist* drawings reflect the artist's investigation of different stylistic techniques during this time. His use of white to define architectural features in the foreground of the watercolor is related to *The Mud Bath*, 1914 (Tate Gallery, London).

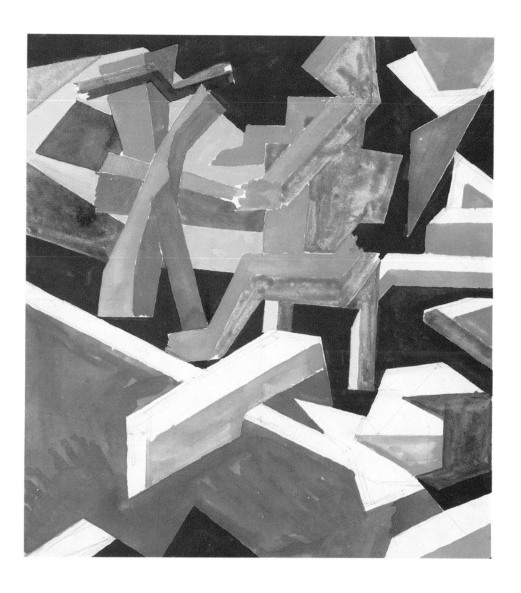

46. *Cubist Composition*

Watercolor, gouache, and pencil on paper,
10⅞ x 10 in.
Executed in 1913

RECORDED: Richard Cork, *David Bomberg*
(1987), p. 54 pl. 5

EXHIBITED: Marlborough Fine Art Ltd., London,
1968, *David Bomberg 1890-1957: Drawings and
Watercolors*, [n.p.] no. 66 // Anthony d'Offay
Gallery, London, 1969, *Abstract Art in England
1913-1915*, p. 46 no. 17 // Hayward Gallery,
London, 1974, *Vorticism and its Allies*, p. 37 no. 30
// Davis and Long Company, New York, 1977,
Vorticism and Abstract Art in the First Machine Age,
[n.p.] no. 6 // Anthony d'Offay Gallery, London,
1986, *Important English Drawings Relating to
Cubism and Vorticism*, [n.p.] no. 5 illus.

EX COLL.: the artist; to estate of the artist, until
1968; to private collection, London, until 1987

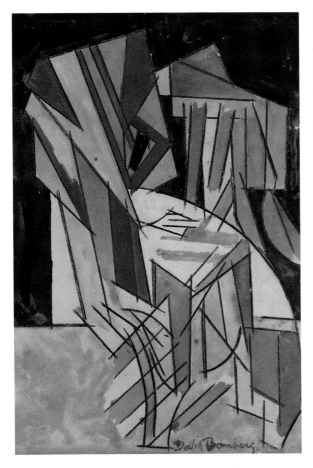

London for its first season at the Covent Garden in 1911, its presence created a sensation. Younger artists were ecstatic. Spencer Gore, for example, commented to the art critic Frank Rutter, "I've often dreamt of such things, but never thought I should see them." Dance became a vital aspect of Vorticist iconography. Gaudier-Brzeska carved *Red Stone Dancer* (Tate Gallery, London), William Roberts painted *Study for Two Step* (British Museum, London), and Wyndham Lewis executed *Kermesse* (now lost). Bomberg's *Dancer* series, which includes both these watercolors, developed the theme of dance with imagination, vigor, and finesse.

48. *The Dancer*

Watercolor, gouache, and crayon on paper, 26½ x 21⅞ in.
Signed (at lower right): Bomberg
Executed about 1913-14

RECORDED: William Lipke, *David Bomberg* (1967), p. 40 // Richard Cork, *Vorticism and Abstract Art in the First Machine Age* (1976), pp. 395 illus., 396-98 // Richard Cork, *David Bomberg* (1987), pp. 94 illus., 95-100 // John McEwen, "Britain's Best and Brightest," in *Art in America* (July 1987), pp. 32-33 illus.

EXHIBITED: Anthony d'Offay Gallery, London, 1969, *Abstract Art in England 1913-1915*, pp. 15, 43 no. 5 illus. // Anthony d'Offay Gallery, London, 1971, *David Bomberg: Drawings, Watercolours and Prints 1912-1925*, [n.p.] no. 5 // Hayward Gallery, London, 1974, *Vorticism and its Allies*, p. 89 no. 364 // Davis and Long Company, New York, 1977, *Vorticism and Abstract Art in the First Machine Age*, [n.p.] no. 9 // Yale Center for British Art, New Haven, Connecticut, 1983, *Blast: The British Answer to Futurism*, [n.p.] no. 7 // Staatsgalerie, Stuttgart, Germany, 1985, *Vom Klang der Bilder*, p. 128 no. 199 // Anthony d'Offay Gallery, London, 1986, *Important English Drawings Relating to Cubism and Vorticism*, [n.p.] no. 8 illus. // Palazzo Grassi, Venice, Italy, 1986, *Futurismo and Futurismi*, p. 295 illus. // Royal Academy of Arts, London, and Staatsgalerie, Stuttgart, Germany, 1987, *British Art in the 20th Century*, p. 149 no. 48 illus.

EX COLL.: the artist; to his estate, until 1968; to private collection, London, until 1987

47. *The Dancer*

Watercolor, gouache, and crayon on paper, 10¾ x 7⅜ in.
Signed (at lower right): David Bomberg
Executed about 1913-14

RECORDED: Richard Cork, *Vorticism and Abstract Art in the First Machine Age* (1976), pp. 392-93, 394 illus., 395-400 // Richard Cork, *David Bomberg* (1987), pp. 94 illus., 95-100

EXHIBITED: Anthony d'Offay Gallery, London, 1969, *Abstract Art in England 1913-1915*, p. 43 no. 7 illus. // Hayward Gallery, London, 1974, *Vorticism and Its Allies*, p. 89 no. 362 // Davis and Long Company, New York, 1977, *Vorticism and Abstract Art in the First Machine Age*, [n.p.] no. 10 // Anthony d'Offay Gallery, London, 1981, *David Bomberg: Works from the Collection of Lilian Bomberg*, [n.p.] no. 10 illus. // Anthony d'Offay Gallery, London, 1986, *Important English Drawings Relating to Cubism and Vorticism*, [n.p.] no. 7

EX COLL.: the artist; to his estate, until 1968; to private collection, London, until 1987

When Serge Diaghilev's Ballet Russe arrived in

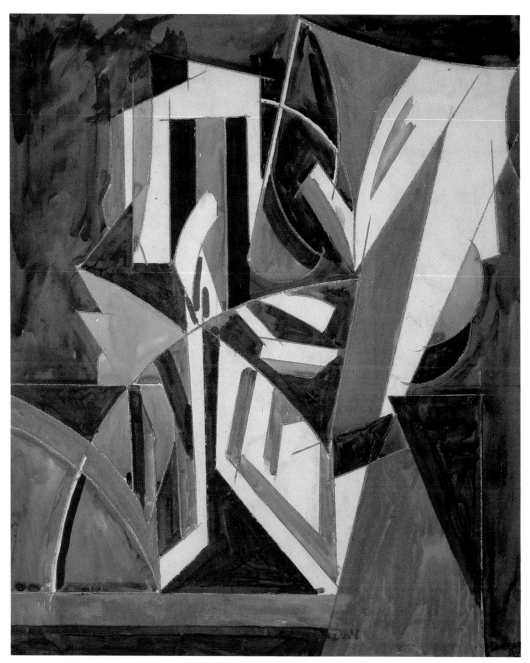

48

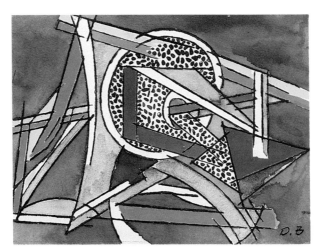

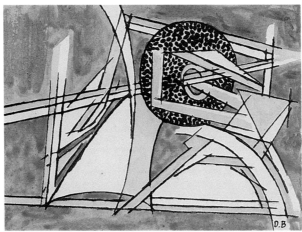

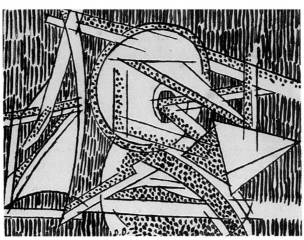

49. *Russian Ballet: Three Studies*

Watercolor, gouache, and ink on paper,
each 3⅞ x 5¼ in.
Each signed (at lower right): D.B.
Each executed in 1914

EXHIBITED: Anthony d'Offay Gallery, London,
1969, *Abstract Art in England 1913-1915*, p. 47
no. 20 illus., one only // Hayward Gallery, London,
1974, *Vorticism and its Allies*, p. 89 no. 369

EX COLL.: the artist; to his estate, until 1972; to
private collection, London, until 1987

These smaller drawings are related to both the
Dancer series and Bomberg's postwar lithographs
(cat. nos. 51a-f), both inspired by Diaghilev's
Russian Ballet.

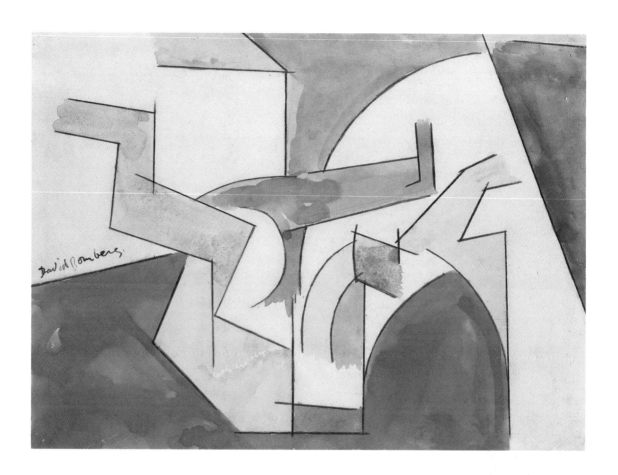

50. *Abstract Composition*

Watercolor and pencil on paper, 10⅞ x 14⅜ in.
Signed (at lower center): David Bomberg
Executed about 1914

RECORDED: Richard Cork, *Vorticism and Abstract Art in the First Machine Age* (1976), p. 390 illus. // Richard Cork, *David Bomberg* (1987), p. 105 pl. 14

EXHIBITED: Anthony d'Offay Gallery, London, 1969, *Abstract Art in England 1913-1915*, p. 45 no. 13 illus. // Davis and Long Company, New York, 1977, *Vorticism and Abstract Art in the First Machine Age*, [n.p.] no. 18 // Yale Center for British Art, New Haven, Connecticut, 1983, *Blast: The British Answer to Futurism*, [n.p.] no. 9 // Anthony d'Offay Gallery, London, 1986, *Important English Drawings Relating to Cubism and Vorticism*, [n.p.] no. 10

EX COLL.: the artist; to his estate, until 1968; to [Anthony d'Offay Gallery, London]; to Peter Palumbo, London; to [Mayor Gallery, London, until 1976]; to private collection, London, until 1987

The paintings which Bomberg exhibited in the first Vorticist exhibition at the Doré Galleries in 1915 were given titles like *Design in White* and *Design in Color*. Bomberg's biographer, Richard Cork, was told by the writer Rebecca West in 1971 that Wyndham Lewis had taken her in 1915 "to see Bomberg's white paintings.... they were all large and abstract." This watercolor, together with *Abstract Design*, 1914 (The Mellon Bank, Pittsburgh, Pennsylvania), is probably related to these early abstractions.

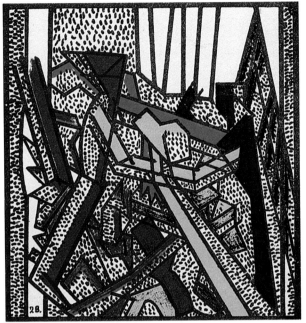

b

d

e

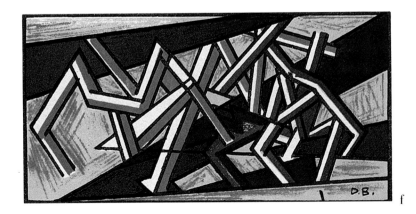

a

f

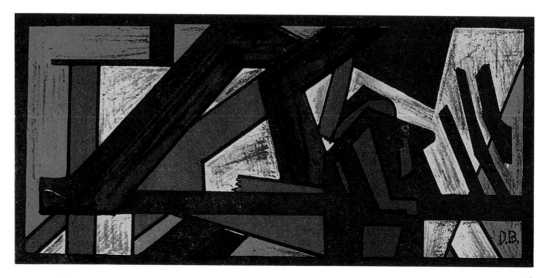

c

51.a. *Russian Ballet*

Color lithograph, 2¼ x 4⅝ in.
Signed in the stone (at lower left): D.B.
Each edition: about 100
Each executed between 1914 and 1919

b. Color lithograph, 4 x 3⅞ in.
Signed in the stone (at lower left): D.B.

c. Color lithograph, 3 x 6¼ in.
Signed in the stone (at lower right): D.B.

d. Color lithograph, 2 x 2⅝ in.
Signed in the stone (at lower left): D.B.

e. Color lithograph, 3 x 2⅝ in.
Signed in the stone (at lower left): D.B.

f. Color lithograph, 3 x 2 in.
Signed in the stone (at lower right): D.B.

RECORDED (for each impression): *cf.* William
Lipke, *David Bomberg* (1967), pl. 11 // *cf.* Richard
Cork, *Vorticism and Abstract Art in the First
Machine Age* (1976), pp. 398, 399 illus., 400 // *cf.*
Richard Cork, *David Bomberg* (1987), pp. 122-23,
124-25 illus., 126

Along with Wadsworth's Vorticist woodcuts,
Bomberg's lithographs are some of the most
innovative prints produced during the early years of
the twentieth century. While Bomberg did not finish
his plates for printing until after World War I, his
basic designs were completed by 1914. Bomberg
printed this set of lithographs in a booklet which
also contained one of his poems:

> Methodic discord startles..../Insistent snatching
> drag fancy from space,/Fluttering white hands
> beat—compel. Reason concedes./Impressions
> crowding collide with movement around us—/
> The curtain falls—the created illusion escapes./
> The mind clamped fast captures only a fragment,
> for new illusion.

Bomberg attempted to sell these prints on two
occasions. At first he and his wife, Alice Mayes,
offered them in 1919 to the audience during a
production of Diaghilev's company at the Alhambra
Theatre. They were found out by Diaghilev, who had
them immediately thrown out of the theatre. Later,
they tried to dispose of them through a London
bookshop, but they were returned unsold. Only a
few sets have survived today.

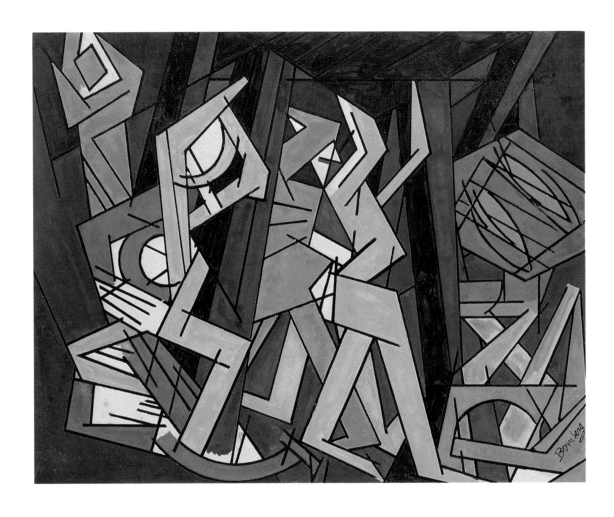

52. *Study for "Sappers at Work: A Canadian Tunnelling Company"*

Oil and watercolor on paper, 9½ x 12⅝ in.
Signed (at lower right): Bomberg
Executed about 1918

RECORDED: William Lipke, *David Bomberg* (1967), p. 47 no. 11 illus. // Richard Cork, *Vorticism and Abstract Art in the First Machine Age* (1976), p. 514 illus. // Richard Cork, *David Bomberg* (1987), pp. 112-13, 114 illus., 115-123

EXHIBITED: Hayward Gallery, London, 1974, *Vorticism and its Allies*, p. 105 no. 453

EX COLL.: the artist; to his estate, until 1971; to private collection, London, until 1987

In 1917 the Canadian War Memorial Fund was established by Max Aitken (later Lord Beaverbrook) with the idea of commissioning a group of large canvases to commemorate Canada's contribution to the War. Edward Wadsworth, William Roberts, Wyndham Lewis, and David Bomberg were each invited to submit designs. As his subject, Bomberg chose an event that took place at St. Eloi Craters, France, in the Spring of 1916: a Canadian Tunnelling Company that had worked underground for eight months planting land minds beneath a German gun battalion.

Bomberg's treatment of the subject was considered too abstract for the War Committee, and he finally executed a more conventional interpretation (National Gallery of Canada, Ottowa). This study, along with another less finished one (private collection, London), are all that survives of Bomberg's initial proposal for the project.

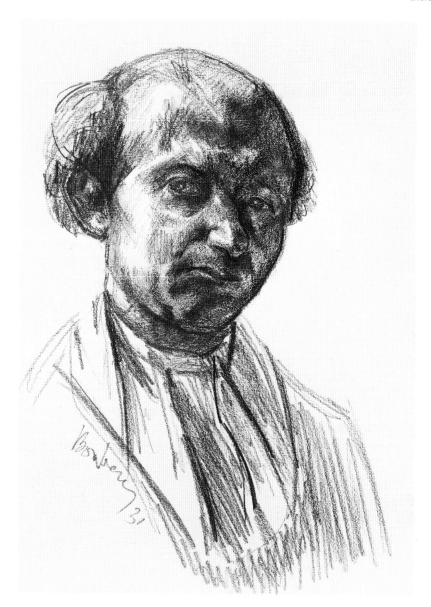

53. *Self-Portrait*

Charcoal on paper, 20 x 13⅞ in.
Signed and dated (at lower left): Bomberg 31

EX COLL.: the artist; to his estate, until 1978; to
private collection, until 1987

JACOB EPSTEIN (1880–1959)

54. *Study for the "Tomb of Oscar Wilde" and a Frieze*

Pencil on paper, 20 x 15 in.
Inscribed (at lower left): covetousness/envy/
jealousy/anger/sloth/wandering thoughts/
fornication/slander/sodomy/evil; (at lower right):
circlet of/sins for double/crown
Executed about 1910

RECORDED: Jacob Epstein, *An Autobiography*
(1955), p. 51 // Richard Buckle, *Jacob Epstein:
Sculptor* (1963), p. 38 no. 51 illus. // Alan G.
Wilkinson, *Gauguin to Moore: Primitivism in
Modern Sculpture* (1981), p. 215 illus. // *cf.* Alan G.
Wilkinson, "Paris and London: Modigliani,
Lipchitz, Epstein and Gaudier-Brzeska," in
"Primitivism" in 20th Century Art, II (1984), p. 431
// Michael Pennington, *An Angel for a Martyr:
Jacob Epstein's Tomb for Oscar Wilde* (1987),
pp. 34, 35 illus., 38–39, illus. as cover

EXHIBITED: Anthony d'Offay Gallery, London,
1973, *Jacob Epstein: The Rock Drill Period*, p. 22
no. 2 illus. // Leeds City Art Galleries, England, and
Whitechapel Art Gallery, London, 1987, *Jacob
Epstein: Sculpture and Drawings*, p. 128 no. 29
illus.

EX COLL.: the artist; to his estate, until 1972; to
private collection, London, until 1987

In 1905, after having spent three years in Paris,
Epstein settled in England. He moved to London,
where he found a studio in Camden Town. He
brought with him an awareness of primitive and
ancient art, sources that continued to inform his
work from this time on. Epstein's second major
commission after arriving in England (his first
commission in 1908 for the British Medical
Association Building in the Strand involved a
controversial series of statues) was a sculptural
program for the Tomb of Oscar Wilde. The project
was begun in 1910 and finally installed in the Père
Lachaise Cemetery in Paris in 1912. Consciously
avoiding traditional Greco-Roman allegory, Epstein
looked instead to non-European precedents such as
Assyrian sculpture, which he had studied in the
British Museum. In this drawing he drew on these
sources and sketched out the basic design of a
program as provocative and controversial as the
Strand statues had been two years earlier.

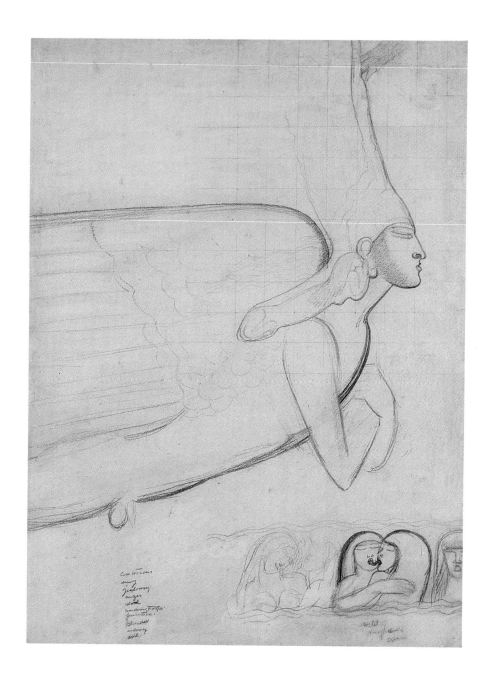

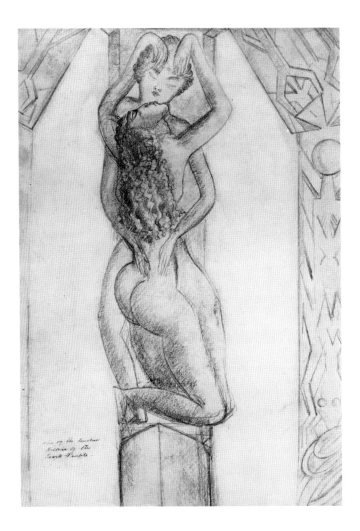

55. *Study for "One of the Hundred Pillars of the Secret Temple"*

Watercolor and pencil on paper, 14½ x 10 in.
Inscribed (at lower left): One of the Hundred Pillars
of the Secret Temple
Executed about 1910

RECORDED: Richard Cork, *Vorticism and Abstract Art in the First Machine Age* (1976), p. 117 illus. // Richard Cork, "The Emancipation of Modern British Sculpture," in *British Art in the 20th Century* (1987), p. 33 illus.

EXHIBITED: Anthony d'Offay Gallery, London, 1973, *Jacob Epstein: The Rock Drill Period*, p. 20 no. 1 illus. // Hayward Gallery, London, 1974, *Vorticism and its Allies*, p. 43 no. 91 // Leeds City Art Galleries, England, and Whitechapel Art Gallery, London, 1987, *Jacob Epstein: Sculpture and Drawings*, p. 146 no. 41 illus.

EX COLL.: the artist; to his estate, until 1972; to private collection, London, until 1987

In 1910 Epstein and his friend, the sculptor and typographer Eric Gill (1882-1940), collaborated on a design for a monumental outdoor sculpture project in celebration of erotic love, procreation, and sensuality. Gill, who was then living in the village of Ditchling, Sussex (Epstein would move to the Sussex coast on his return from Paris in 1912), proposed a possible site for the program on the side of one of the Sussex Downs next to Asheham House. (Asheham House later became the residence of Virginia Woolf and a central gathering place for Bloomsbury artists.) Although the project never materialized, this drawing and several carvings by Gill attest to its initial phases of consideration.

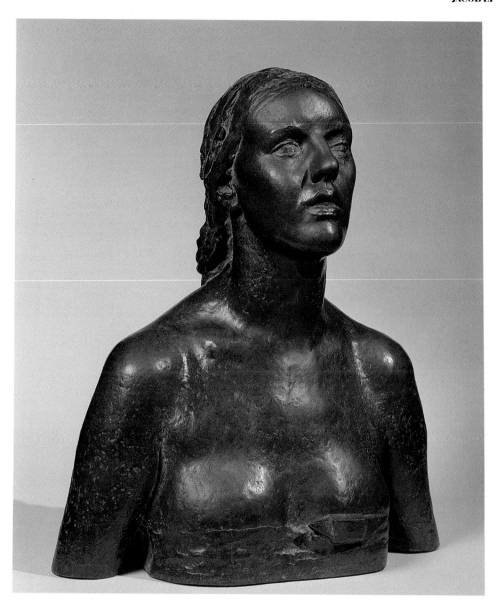

56. *Second Portrait of Euphemia Lamb*

Bronze, 21½ in. high

Executed in 1911

RECORDED: *cf:* Van Deren, *Epstein* (1920), pl. XVII // *cf.* Arnold Haskell, *The Sculptor Speaks, Jacob Epstein to Arnold Haskell, A Series of Conversations on Art* (1931), p. 168 // *cf.* Jacob Epstein, *Let There Be Sculpture* (1940), p. 56 // *cf.* R. Black, *The Art of Jacob Epstein* (1942), p. 182 no. 21 // *cf.* Jacob Epstein, *An Autobiography* (1955), p. 42 // *cf.* Richard Buckle, *Jacob Epstein: Sculptor* (1963), p. 52 no. 74 illus. // Evelyn Silber *The Sculpture of Epstein* (1986), pp. 128-29 no. 33 illus.

EX COLL.: the artist; to R. A. Bevan, until 1974; to private collection, London, until 1987

Euphemia Lamb (born Nina Forrest) was a famous English model in the early years of the twentieth century who, in addition to Epstein, also sat for Augustus John, William Orpen, and her husband Henry Lamb. Epstein modeled his first bust of her in 1908 (Tate Gallery, London). Epstein also modeled a full-length statue of Euphemia Lamb as a *Fountain Figure* for Lady Ottoline Morrell. This is one of four casts.

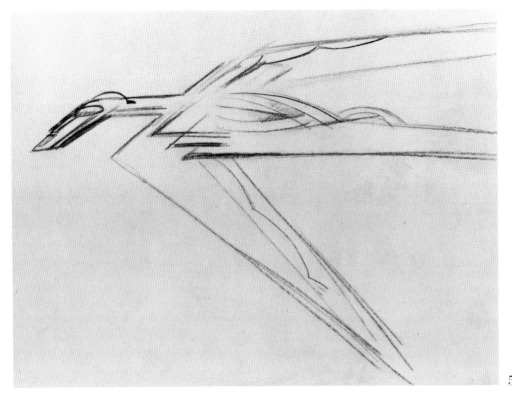

57

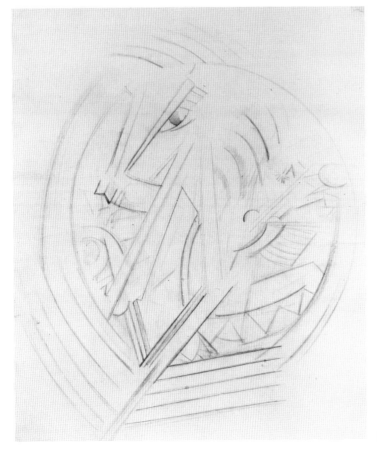

58

57. *Study of a Winged Figure*

Blue crayon on paper, 20½ x 25 in.
Executed about 1912-13

RECORDED: Richard Cork, *Vorticism and Abstract Art in the First Machine Age* (1976), pp. 463-64 illus.

EXHIBITED: Anthony d'Offay Gallery, London, 1973, *Jacob Epstein: The Rock Drill Period*, p. 28 no. 5 // Hayward Gallery, London, 1974, *Vorticism and its Allies*, p. 72 no. 228 // Davis and Long Company, New York, 1977, *Vorticism and Abstract Art in the First Machine Age*, [n.p.] no. 25 // Leeds City Art Galleries, England, and Whitechapel Art Gallery, London, 1987, *Jacob Epstein: Sculpture and Drawings*, p. 56 no. 59 illus.

EX COLL.: the artist; to his estate, until 1970; to private collection, London, until 1987

58. *Study for "Birth"*

Charcoal and pencil on paper, 24⅜ x 20⁵⁄₁₆ in.
Executed about 1913

EXHIBITED: Anthony d'Offay Gallery, London, 1969, *Abstract Art in England 1913-1915*, pp. 25, 48 no. 24 illus. // Anthony d'Offay Gallery, London, 1973, *Jacob Epstein: The Rock Drill Period*, p. 32 no. 7 illus. // Davis and Long Company, New York, 1977, *Vorticism and Abstract Art in the First Machine Age*, [n.p.] no. 27 // Leeds City Art Galleries, England, and Whitechapel Art Gallery, London, 1987, *Jacob Epstein: Sculpture and Drawings*, p. 156 no. 53 illus.

EX COLL.: the artist; to his estate, until 1964; to private collection, London, until 1987

Epstein's drawings and sculpture between 1913 and 1914 focus on themes of sexuality, particularly copulation, pregnancy, and birth. As a major theme in Epstein's work, maternity first appeared in 1908 in one of the Strand statues. It reappeared in a series of drawings and sculptures of 1913, including *Flenite Relief* (private collection, New York) and *Figures in Flenite* (The Minneapolis Institute of Arts, Minnesota).

59. *Study for "Female Figure in Flenite"*

Charcoal on paper, 27 x 16¾ in.
Signed (at lower left): Epstein
Executed about 1913

RECORDED: Richard Cork, *Vorticism and Abstract Art in the First Machine Age* (1976), p. 120 illus. // Alan G. Wilkinson, *Gauguin to Moore: Primitivism in Modern Sculpture* (1981), p. 175 illus. // Alan G. Wilkinson, "Paris and London: Modigliani, Lipchitz, Epstein and Gaudier-Brzeska," in *"Primitivism" in 20th Century Art*, II (1984), p. 434

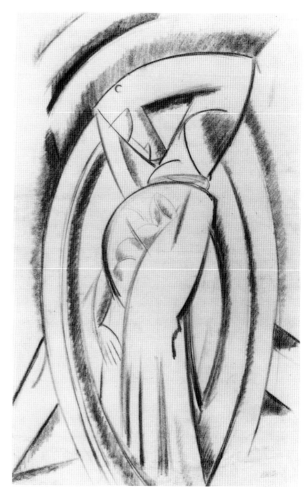

59

EXHIBITED: Anthony d'Offay Gallery, London, 1973, *Jacob Epstein: The Rock Drill Period*, p. 38 no. 10 illus. // Hayward Gallery, London, 1974, *Vorticism and its Allies*, p. 43 no. 95 // Davis and Long Company, New York, 1977, *Vorticism and Abstract Art in the First Machine Age*, [n.p.] no. 34 // Palazzo Grassi, Venice, Italy, 1986, *Futurismo and Futurismi*, p. 300 illus. // Anthony d'Offay Gallery, London, 1986, *Important English Drawings Relating to Cubism and Vorticism*, [n.p.] no. 15 illus. // Leeds City Art Galleries, England, and Whitechapel Art Gallery, London, 1987, *Jacob Epstein: Sculpture and Drawings*, p. 155 no. 51 illus.

EX COLL.: the artist; to his estate; to Edward P. Schinman, until 1972; to private collection, London, until 1987

This drawing is a preliminary study for *Figure in Flenite* (The Minneapolis Institute of Arts, Minnesota) and *Female Figure in Flenite* (Tate Gallery, London).

60. *Study for "Rock Drill" (Back View)*

Charcoal on paper, 26⅝ x 16 in.
Signed and inscribed (at lower right): Study for
Rock Drill/Epstein
Executed about 1913

RECORDED: T.E. Hulme, "Contemporary
Drawings Series No. 1," in *The New Age* (1913) //
Richard Buckle, *Jacob Epstein: Sculptor* (1963),
p. 68 no. 93 illus. // Richard Cork, *Vorticism and
Abstract Art in the First Machine Age* (1976), pp.
467-68, 469 illus.

EXHIBITED: Anthony d'Offay Gallery, London,
1973, *Jacob Epstein: The Rock Drill Period*, p. 46
no. 14 illus. // Hayward Gallery, London, 1974,
Vorticism and its Allies, p. 73 no. 236 // Davis and
Long Company, New York, 1977, *Vorticism and
Abstract Art in the First Machine Age*, [n.p.] no. 31
// Yale Center for British Art, New Haven,
Connecticut, 1983, *Blast: The British Answer to
Futurism*, [n.p.] no. 11 // Palazzo Grassi, Venice,
Italy, 1986, *Futurismo and Futurismi*, p. 299 illus.
// Anthony d'Offay Gallery, London, 1986,
*Important English Drawings Relating to Cubism
and Futurism*, [n.p.] no. 12 illus. // Leeds City Art
Gallery, England, and Whitechapel Art Gallery,
London, 1987, *Jacob Epstein: Sculpture and
Drawings*, p. 166 no. 67 illus.

EX COLL.: the artist; to his estate; to Edward P.
Schinman, until 1972; to private collection,
London, until 1987

61. *Study for "Rock Drill" (Drill's Head)*

Charcoal on paper, 27 x 16 in.
Signed (at lower left): Epstein
Executed about 1913

RECORDED: Richard Cork, *Vorticism and Abstract
Art in the First Machine Age* (1976), p. 470 illus.

EXHIBITED: Anthony d'Offay Gallery, London,
1973, *Jacob Epstein: The Rock Drill Period*, p. 48
no. 15 illus. // Hayward Gallery, London, 1974,
Vorticism and its Allies, p. 73 no. 239 // Davis and
Long Company, New York, 1977, *Vorticism and
Abstract Art in the First Machine Age*, [n.p.] no. 29
// Philadelphia Museum of Art, Pennsylvania,
1980-81, *Futurism and the International Avant-
Garde*, [n.p.] no. 78 illus. // Palazzo Grassi, Venice,
Italy, 1986, *Futurismo and Futurismi*, p. 299 illus.
// Anthony d'Offay Gallery, London, 1986,
*Important English Drawings Relating to Cubism
and Vorticism*, [n.p.] no. 13 // Leeds City Art
Gallery, England, and Whitechapel Art Gallery,
London, 1987, *Jacob Epstein: Sculpture and
Drawings*, p. 166 no. 68

EX COLL.: the artist; to his estate, until 1975; to
private collection, London, until 1987

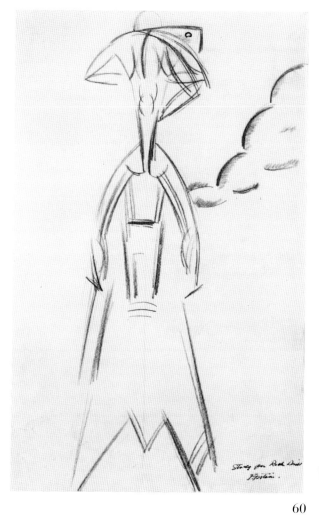

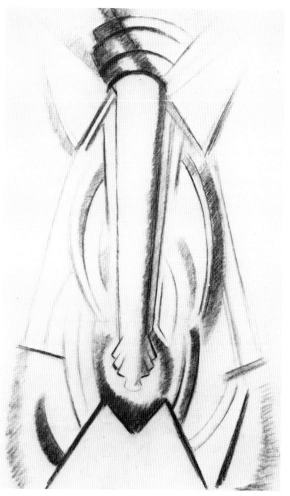

60

61

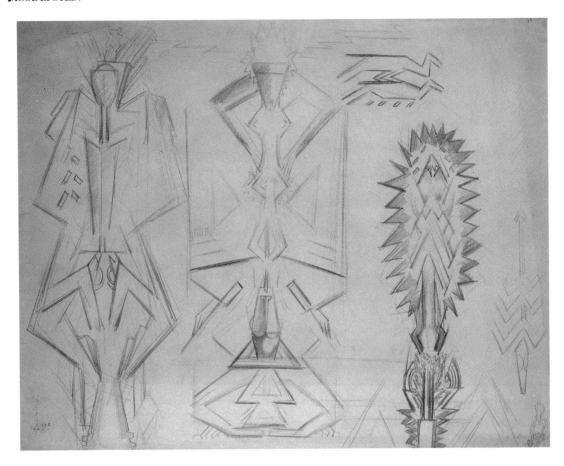

62. *Six Studies for "Rock Drill" and "Doves"*

Colored crayon and pencil on paper, 17⅝ x 22⅝ in. Executed about 1913

RECORDED: Evelyn Silber, *The Sculpture of Epstein* (1986), p. 16 no. 13 illus. // Richard Cork, *Vorticism and Abstract Art in the First Machine Age* (1976), pp. 466 illus., 467 // Richard Cork, "Wyndham Lewis and the Drogheda dining-room," in *The Burlington Magazine* (Oct. 1984), p. 615 no. 21 illus. // Alan G. Wilkinson, "Paris and London: Modigliani, Lipchitz, Epstein and Gaudier-Brzeska," in *"Primitivism" in 20th Century Art*, II (1984), pp. 339-40 illus.

EXHIBITED: London Arts Group, [n.d.], *Epstein: Retrospective Exhibition of Sculpture and Drawings*, [n.p.] no. 56 illus. // Anthony d'Offay Gallery, London, 1973, *Jacob Epstein: The Rock Drill Period*, p. 36 no. 9 illus. // Hayward Gallery, London, 1974, *Vorticism and its Allies*, p. 72 no. 233 // Davis and Long Company, New York, 1977, *Vorticism and Abstract Art in the First Machine Age*, [n.p.] no. 32 // Anthony d'Offay Gallery, London, 1986, *Important English Drawings Relating to Cubism and Futurism*, [n.p.] no. 94 // Leeds City Art Galleries, England, and Whitechapel Art Gallery, London, 1987, *Jacob Epstein: Sculpture and Drawings*, p. 163 no. 61 illus.

EX COLL.: the artist; to his estate, until 1972; to private collection, London, until 1987

Epstein executed many preliminary drawings for *The Rock Drill*. In these he revealed his persistent interest in primitive art. Alan Wilkinson wrote about these studies [*loc. cit.*]: "The numerous preparatory drawings for *The Rock Drill* confirm that Epstein had not in fact rid himself entirely of the influences of tribal art. There are more drawings for this sculpture than for any of Epstein's sculptures of the period. These drawings reveal the genesis and complex transformation of the ideas for the sculpture, some of which are closely related to earlier primitivistic works such as the drawing *Totem* (Tate Gallery, London) and the stone *Sunflower* (National Gallery of Victoria, Melbourne, Australia)."

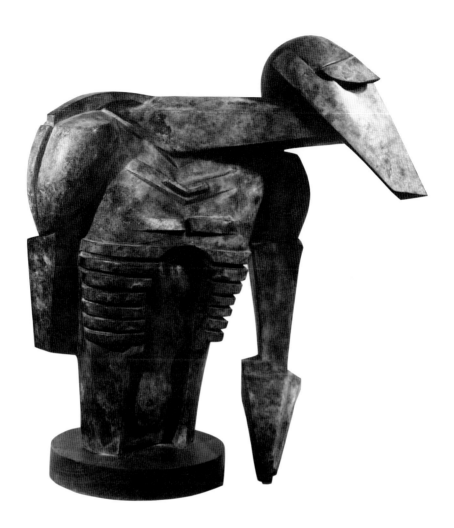

63. *Torso in metal from The Rock Drill*

Bronze, 27¾ x 23 x 17½ in.
Executed in 1913-14

RECORDED: *cf.* B. Van Deren, *Epstein* (1920),
pp. 33, 44, 47, 50, pl. XIII // *cf.* H. Wellington,
Jacob Epstein (1925), pp. 17-18, pl. 4 // *cf.* R. Black,
The Art of Jacob Epstein (1942), no. 32, pls. 40-41,
dated 1913 // *cf.* Richard Buckle, *Jacob Epstein
Sculptor* (1963), pp. 66-68, pl. 95-96 // *cf.* Richard
Cork, *Vorticism and Abstract Art in the First
Machine Age* (1976), pp. 478-81 illus. // *cf.* Evelyn
Silber, *The Sculpture of Epstein* (1986), p. 135
no. 54 pl. 12.

Lent by The Museum of Modern Art, New York.
Mrs. Simon Guggenheim Fund, 1962

Generally considered a quintessential Vorticist
sculpture, *The Rock Drill* was based to a large extent
on tribal sculpture. Primitivistic inflections were
incorporated into the object which became a
poignant comment on contemporary English
culture, as well as an atavistic nightmare. In his
Autobiography (1963), Epstein wrote about the
conception of the work:

> It was in the experimental prewar days of 1913
> that I was fired to do the rock drill, and my ardour
> for machinery (short-lived) expended itself upon
> the purchase of an actual drill, secondhand, and
> upon this I made and mounted a machine-like
> robot, visored, menacing, and carrying within
> itself its progeny, protectively ensconced. Here is
> the armed, sinister figure of today and tomorrow.
> No humanity, only the terrible Frankenstein's
> monster we have made ourselves into.

The finished model was exhibited with The London
Group in 1915. And Epstein recalled that Henri
Gaudier-Brzeska was enthusiastic about it when he
visited his studio with Ezra Pound in 1913.

HENRI GAUDIER-BRZESKA (1891-1915)

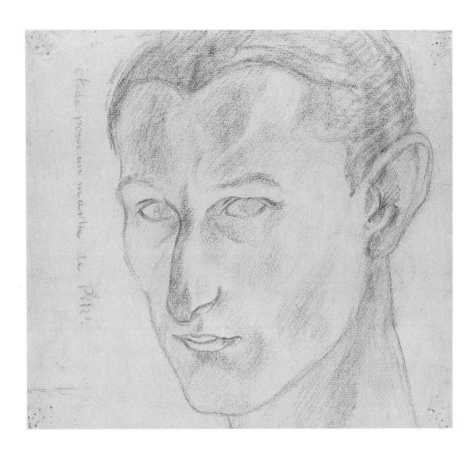

64. *Self-Portrait*

Pencil on paper, 11 x 12¼ in.
Inscribed (in left margin): etude pour
un maske de Pik
Executed about 1911-12

EXHIBITED: Anthony d'Offay Gallery, London,
1980, *Henri Gaudier-Brzeska: Drawings and
Pastels*, [n.p.] no. 1 // David Jones Art Gallery,
Sydney, Australia, 1981, *Drawings and Sculpture
by Henri Gaudier-Brzeska 1891-1915*, [n.p.] no. 1
// Kettle's Yard Gallery, Cambridge, City of Bristol
Museum and Art Gallery, and York City Art Gallery,
England, 1983-84, *Henri Gaudier-Brzeska,
Sculptor 1891-1915*, p. 33 no. 4 illus. // Galleria
Pieter Coray, Lugano, Italy, 1984, *Henri Gaudier-
Brzeska*, [n.p.] no. 1, illus. as frontispiece

EX COLL.: the artist; to Ezra Pound; to private
collection, until 1980; to private collection, London,
until 1987

This self-portrait was probably intended as a study
for a sculpted mask. Stylistically, it is related to
Head of an Idiot (cat no. 65). The inscription on the
drawing refers to the nickname given to Gaudier-
Brzeska by his companion Sophie.

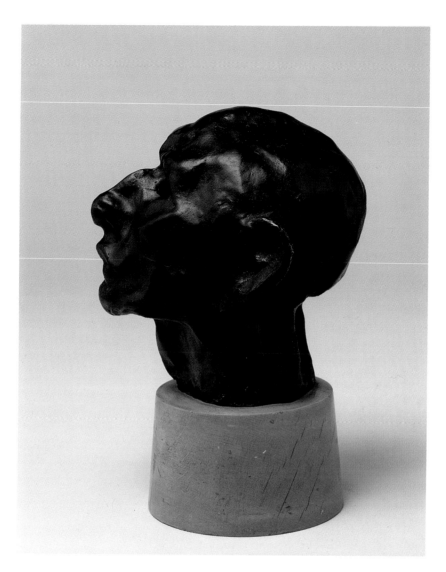

65. *Head of an Idiot*

Bronze, 10 in. high
Executed in 1912

RECORDED: *cf.* Horace Brodsky, *Henri Gaudier-Brzeska 1891-1915* (1933), opp. p. 66 illus. // *cf.* Mervyn Levy, *Gaudier-Brzeska: Drawings and Sculpture* (1965), p. 75 illus. // *cf.* Roger Cole, *Burning to Speak: The Life and Art of Henri Gaudier-Brzeska* (1978), p. 65 no. 18 // *cf.* Roger Secretain, *Un sculpteur "maudit": Gaudier-Brzeska 1891-1915* (1979), p. 107 illus.

EXHIBITED: *cf.* Leicester Galleries, London, 1918, *Henri Gaudier-Brzeska: Memorial Exhibition*, no. 21 // *cf.* Arts Council of Great Britain, London, 1956, *Henri Gaudier-Brzeska*, no. 3 // *cf.* Tate Gallery, London, 1956, *Wyndham Lewis and Vorticism*, no. 171 // *cf.* Kunsthalle, Bielefeld, Germany, 1969, *Henri Gaudier-Brzeska 1891-1915*, no. 2 illus. // David Jones Art Gallery, Sydney, Australia, 1981, *Drawings and Sculpture by Henri Gaudier-Brzeska 1891-1915*, [n.p.] no. 2 // *cf.* Kettle's Yard Gallery, Cambridge, City of Bristol Museum and Art Gallery, and York City Art Gallery, England, 1983-84, *Henri Gaudier-Brzeska: Sculptor 1891-1915*, no. 13

EX COLL.: [Zwemmer Gallery, London]; to [Adams Gallery, London, 1965]; to private collection, London, until 1987

This satirical self-portrait, with its expressionistic modeling and psychological intensity, has affinities to Rodin's bronzes and Gericault's earlier portraits of the insane. This is one of seven bronzes cast in London in 1939 by Anton Zwemmer. The original plaster is in the Victoria and Albert Museum, London.

66. *Portrait of Claud Lovat Fraser*

Pastel and watercolor on paper, 10⅛ x 8 in.
Inscribed and dated (at upper right): By Gaudier/
March 1912

EXHIBITED: Anthony d'Offay Gallery, London,
1980, *Henri Gaudier-Brzeska: Drawings and
Pastels*, [n.p.] no. 5 // David Jones Art Gallery,
Sydney, Australia, 1981, *Drawings and Sculpture
by Henri Gaudier-Brzeska 1891-1915*, [n.p.] no. 4

EX COLL.: the artist; to Claud Lovat Fraser; to
Mrs. Claud Lovat Fraser; to private collection,
London, until 1987

This pastel is one of a small number of portraits
Gaudier-Brzeska made of his friends—devotees of
theatre, literature, and the fine arts. Claude Lovat
Fraser (1890-1921) was an illustrator and theatre
designer, who, like the sculptor, died at an early age.

67. *Omega Box with Animals*

Gouache on wood, 4½ x 8½ in.
Executed in 1913

EXHIBITED: Anthony d'Offay Gallery, 1984, *The
Omega Workshops: Alliance and Enmity in English
Art 1911-1920*, [n.p.] no. 123 illus.

Small hand-painted objects such as fans and pencil
boxes were popular items at the Omega showrooms.
Although all works were inscribed with the Omega
symbol and sold anonymously, this box has been
attributed to Gaudier-Brzeska.

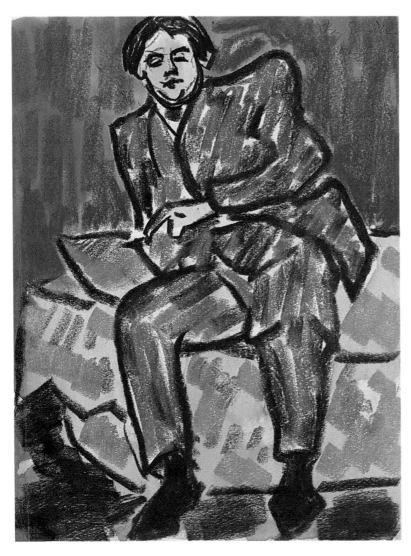

66

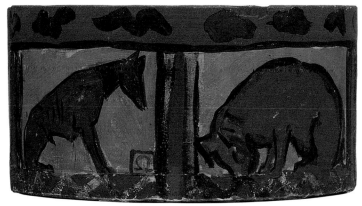

67

68. *Cat*

Ceramic with pale green glaze, 5 x 4 in.
Executed in 1913

RECORDED: Horace Brodsky, *Henri Gaudier-Brzeska 1891-1915* (1933), opp. p. 124 illus. // *cf.* Roger Cole, *Burning to Speak: The Life and Art of Henri Gaudier-Brzeska* (1978), p. 88 no. 37 illus.

EXHIBITED: Arts Council of Great Britain, London, 1956, *Henri Gaudier-Brzeska*, p. 10 no. 18 // *cf.* Kettle's Yard Gallery, Cambridge, City of Bristol Museum and Art Gallery, and York City Art Gallery, England, 1983-84, *Henri Gaudier-Brzeska: Sculptor 1891-1915*, p. 46 no. 45 illus. // Anthony d'Offay Gallery, London, 1984, *The Omega Workshops: Alliance and Enmity in English Art 1911-1920*, [n.p.] no. 146

EX COLL.: the artist; to Mrs. Robert P. Bevan; to R.A. Bevan, until 1974; to private collection, London, until 1987

In addition to his sculptural undertakings, Gaudier-Brzeska also executed designs for the Omega Workshops. Animal imagery was a prominent theme of Omega designs, as seen in Roger Fry's *Giraffe Cupboard*, Duncan Grant's *Elephant and Rider Tray*, and Vanessa Bell's *Nursery* installation. *Cat* is related to a group of miniature sculptures— *Cheetah, Dog, Sleeping Faun,* and *Stag*—that Gaudier-Brzeska made between 1912 and 1914. *Cat* was first modeled in clay before being cast in an edition of six. Each cast was glazed with a different color.

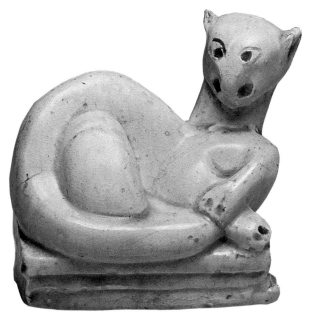

68

69. *Portrait of Wyndham Lewis*

Charcoal on paper, 15 x 9⅞ in.
Executed about 1913-14

RECORDED: Seamus Cooney, ed., *BLAST 3*
(1984), illus. as frontispiece // *Enemy News*, no. 19
(1984), illus. as frontispiece

EXHIBITED: Anthony d'Offay Gallery, London,
1980, *Henri Gaudier-Brzeska: Drawings and
Pastels*, [n.p.] no. 30 // Kettle's Yard Gallery,
Cambridge, City of Bristol Museum and Art Gallery,
and York City Art Gallery, England, 1983-84, *Henri
Gaudier-Brzeska, Sculptor 1891-1915*, no. 75 //
Palazzo Grassi, Venice, Italy, 1986, *Futurismo and
Futurismi*, p. 303 illus.

EX COLL.: the artist; to Ezra Pound; to private
collection, until 1980; to private collection, London,
until 1987

Although Wyndham Lewis and Gaudier-Brzeska
did not know each other well, they respected each
other's work and were closely associated through
various avant-garde publications, groups, and
exhibitions. Lewis saw Gaudier-Brzeska as a figure
"preternaturally alive"...and considered him "an
extremely fine artist...a placid genius of gentle and
rounded shapes." This portrait was executed during
the artists' most fruitful years of association.

70. *Head of Ezra Pound*

Ink on paper, 19½ x 14½ in.
Executed about 1913-14

RECORDED: Horace Brodsky, *Henri Gaudier-Brzeska 1891-1915* (1933), p. 59 // Mervyn Levy, *Gaudier-Brzeska: Drawings and Sculpture* (1965), p. 12 illus., and illus. as cover // Richard Cork, *Vorticism and Abstract Art in the First Machine Age* (1976), p. 181 illus. // Roger Secretain, *Un sculpteur "maudit": Gaudier-Brzeska 1891-1915* (1979), p. 188 illus. // Richard Cork, *Henri Gaudier-Brzeska and Ezra Pound: A Friendship* (1982), p. 10 illus. // Seamus Cooney, ed. *BLAST 3* (1984), p. 157 illus. // Francine A. Koslow, "Gaudier-Brzeska and Ezra Pound," in *The Print Collector's Newsletter*, XVI (Nov.-Dec. 1985), p. 153 illus.

EXHIBITED: Marlborough Fine Art Ltd., London, 1965, *Gaudier-Brzeska 1891-1915*, [n.p.] no. 34 // Anthony d'Offay Gallery, London, 1980, *Henri Gaudier-Brzeska: Drawings and Pastels*, [n.p.] no. 37 // Kettle's Yard Gallery, Cambridge, City of Bristol Museum and Art Gallery, and York City Art Gallery, 1983-84, *Henri Gaudier-Brzeska, Sculptor 1891-1915*, p. 53 no. 72 // Galleria Pieter Coray, Lugano, Italy, 1984, *Henri Gaudier-Brzeska*, [n.p.] no. 5 illus. // Tate Gallery, London, 1985, *Ezra Pound's Artists*, [n.p.] no. 4

EX COLL.: the artist; to his estate; to H.S. Ede; to [Marlborough Fine Art Ltd., London, 1965]; to Benjamin Sonnenberg, Jr., New York; to private collection, London, until 1987

Gaudier-Brzeska worked out the general character of his *Hieratic Head of Ezra Pound* in numerous preliminary sketches. This drawing is related to others in the Musee National d'Art Moderne, Paris, and in Kettle's Yard Gallery, University of Cambridge, England.

71. *Hieratic Head of Ezra Pound*
Marble, 36 x 19 x 16½ in.
Executed in 1914

RECORDED: H.S. Ede, *Savage Messiah* (1931),
p. 258 // Horace Brodsky, *Henri Gaudier-Brzeska
1891-1915* (1933), pp. 58-62 // Ezra Pound, *Henri
Gaudier-Brzeska, Con un Manifesto Vorticista*
(1957), [n.p.] no. 9 illus. // Ezra Pound, *Gaudier-
Brzeska: A Memoir* (1960), pp. 48 ff, illus. as
frontispiece and pls. XIII, XXIX // Mervyn Levy,
Gaudier-Brzeska: Drawings and Sculpture (1965),
p. 30 pl. 78 // Richard Cork, *Vorticism and Abstract
Art in the First Machine Age* (1976), pp. 179-84
illus. // Roger Cole, *Burning to Speak: The Life and
Art of Henri Gaudier-Brzeska* (1978), pp. 36, 102 //
Jeremy Lewison, ed., *Henrié Gaudier-Brzeska:
Sculptor 1891-1915* (1983), pp. 4, 24, 53 illus. //
Alan G. Wilkinson, "Paris and London: Modigliani,
Lipchitz, Epstein and Gaudier-Brzeska," in
"Primitivism" in 20th Century Art, II (1984), p. 448
illus. // Francine A. Koslow, "Gaudier-Brzeska and
Ezra Pound," in *The Print Collector's Newsletter*,
XVI (Nov.-Dec. 1985), pp. 153, 154 illus., 155-59
nos. 1 and 2 // *Henrié Gaudier-Brzeska 1891-1915:
Vu et Raconte par Les Eleves du Lycée
Professionnel de Saint-Jean-de-Braye* (1986),
pp. 4, 8, 123

EXHIBITED: Whitechapel Art Gallery, London,
1914, *Twentieth Century Art*, no. 154 // Milan, Italy,
1957, *XI Triennale di Milano*, no. 9 // Anthony
d'Offay Gallery, London, 1982, *Henri Gaudier-
Brzeska and Ezra Pound: A Friendship*, [n.p.]
[n.n.] illus.//Tate Gallery, London, 1985, *Ezra
Pound's Artists*, [n.p.] no. 1//Royal Academy of
Arts, London and Staatsgalerie, Stuttgart,
Germany, 1987, *British Art in the 20th Century*, p.
410 no. 58 illus.

EX COLL: the artist; to Ezra Pound; to private
collection, on loan to the Tate Gallery, London,
1982-87

In his *Gaudier-Brzeska: A Memoir*, Ezra Pound
described his first encounter with the young sculptor
at the Allied Artists Association in the Royal Albert
Hall, London. While walking through the upper
galleries "hunting for new work and trying to find
some good amid much bad," Pound noticed that he
was being followed by "a young man...like a well
made young wolf or some soft morning, bright-eyed
wild thing." Coming to the ground floor of the
exhibition, Pound was impressed by "a figure with
bunchy muscles done in clay and painted green,"
but he was dismayed when he attempted to
pronounce the artist's name. Pound recalled:
"'Brzxjk,' I began. I tried again. 'Burrzisskzk—' I
drew back, breathed deeply and took another run at
the hurdle, sneezed, coughed, rumbled, got as far as
'Burdidis' when there was a dark tram behind the
pedestal and I heard a voice speaking with the
gentlest fury in the world, 'Cela s'appelle tout
simplement Jaersh-ka. C'est moi qui les ai sculptés.'
And he disappeared like a Greek god in a vision."

The friendship that consequently developed
between the poet and the sculptor was central to the
development of modernism in England. At Gaudier-
Brzeska's suggestion, Pound began a long series of
sittings that culminated in the *Hieratic Head*. As the
sculptor became increasingly absorbed in its
monumental qualities, the sculpture began to lose
any obvious resemblance to Pound's appearance.
The sculptor said to the poet: "You understand, it
will not look like you, it *will not look* like you. It will
be the expression of certain emotions which I get
from your character." Gaudier-Brzeska, like Jacob
Epstein, looked to primitive sources for new
sculptural models. Out of his studies came his
dedication to direct carving, an important and
central aspect of his work. While many of Gaudier-
Brzeska's pieces have a generic affinity to tribal
soürces, *The Hieratic Head* is related to a specific
work: the monumental Easter Island figure *Hoa-
Haka-Nana-Ia*, which was acquired by the British
Museum in 1869.

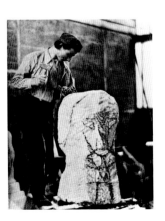

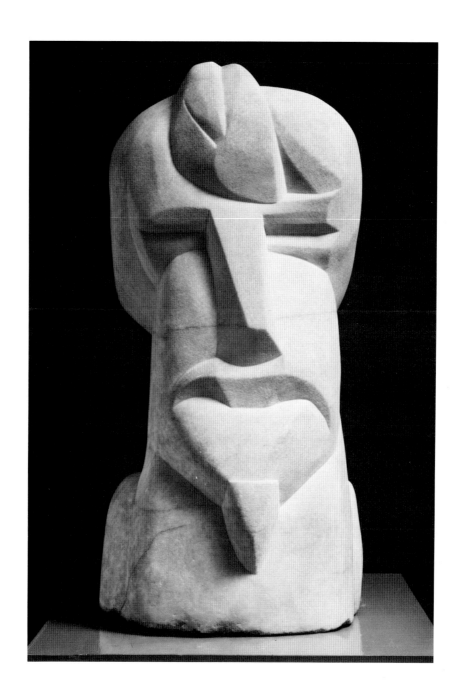

72. *Vorticist Composition, Drawing from Hieratic Head of Ezra Pound*

Pencil on paper, 7 x 4½ in.
Executed about 1914

EXHIBITED: Tate Gallery, London, 1985, *Ezra Pound's Artists*, no. 2 // Anthony d'Offay Gallery, London, 1986, *Important English Drawings Relating to Cubism and Vorticism*, [n.p.] no. 17 illus.

EX COLL.: the artist; to his estate; to H.S. Ede; to [Browse & Darby, Ltd., London, 1981]; to private collection, London, until 1987

This drawing was probably executed after the completion of the *Hieratic Head*, and it demonstrates the degree to which Gaudier-Brzeska pushed his sculptural ideas toward abstraction.

73. *Mother and Child, Drawing for Sculpture*

Ink and pencil on paper, 9¼ x 5⅛ in.
Executed about 1914

EXHIBITED: Kettle's Yard Gallery, Cambridge, City of Bristol Museum and Art Gallery, and York City Art Gallery, England, 1983-84, *Henri Gaudier-Brzeska, Sculptor 1891-1915*, p. 60 no. 107 illus., as *Man Carrying Load, Drawing for Sculpture*

EX COLL.: Roger Cole, England, 1977; to private collection, London, until 1987

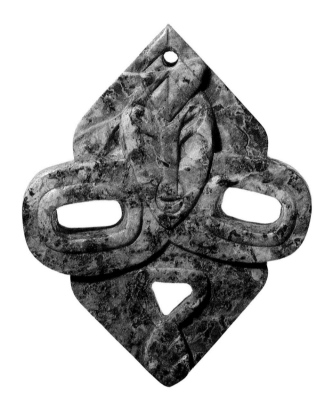

74. *Charm*

Green stone, 4½ x 3½ in.
Executed in 1914

RECORDED: Ezra Pound, *Gaudier-Brzeska: A Memoir* (1916), illus. as cover // Roger Cole, *Burning to Speak: The Life and Art of Henri Gaudier-Brzeska* (1978), p. 111 no. 58 // Alan G. Wilkinson, "Paris and London: Modigliani, Lipchitz, Epstein and Gaudier-Brzeska," in *"Primitivism" in 20th Century Art*, II (1984), p. 447 illus.

EXHIBITED: Doré Galleries, London, 1915, *Vorticist Exhibition*, no. C // Leicester Galleries, London, 1918, *Henri Gaudier-Brzeska: Memorial Exhibition*, no. 22 // Galleria Apollinaire, Milan, Italy, 1957, *Henri Gaudier-Brzeska*, [n.p.] no. 2 illus. // The Museum of Modern Art, New York, 1984, *"Primitivism" in 20th Century Art*, p. 447 illus.

EX COLL.: the artist; to Ezra Pound; to private collection, until 1982; to private collection, London, until 1987

In the last years of his life Gaudier-Brzeska carved and cast a number of miniature sculptures in metal, stone, and bone. He gave most of these as gifts to his closest friends. To T. E. Hulme, for instance, he gave *Ornament Torpille* (Art Gallery of Ontario, Canada), and this charm was given to Ezra Pound, who not only wore it around his neck, but had its design embossed on the front cover of his *Memoir* of Gaudier-Brzeska, a year after the sculptor's death.

WYNDHAM LEWIS (1882-1957)

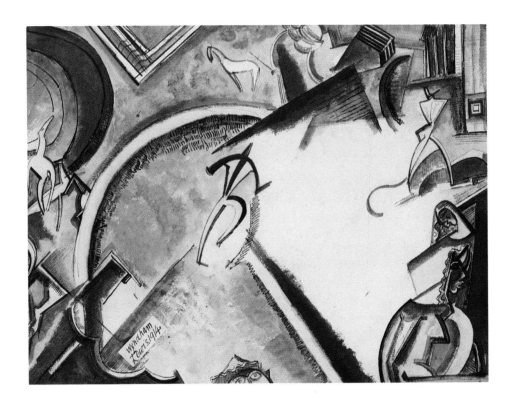

75. *Cabaret Theatre Scene*

Watercolor, ink, and collage on paper, 9⅜ x 12½ in.
Signed and dated (at lower left): Wyndham Lewis
1913/1914

RECORDED: Walter Michel, *Wyndham Lewis:
Paintings and Drawings* (1974), p. 358 no. 160 pl.
24, as *Circus Scene*

EXHIBITED: The Tate Gallery, London, 1956,
Wyndham Lewis and Vorticism, p. 15 no. 37, as
Circus Scene // Anthony d'Offay Gallery, London,
1983, *Wyndham Lewis: Drawings and Watercolours
1910-1920*, [n.p.] no. 15 illus. // Anthony d'Offay
Gallery, London, 1984, *The Omega Workshops:
Alliance and Enmity in English Art 1911-1920*,
[n.p.] no. 90

EX COLL.: the artist; to Edward Wadsworth; to
private collection, London, until 1987

In *Cabaret Theatre Scene* Lewis depicted a circus
from a combination of viewpoints. Circus
performers—the ringmaster, horses, clowns,
jugglers, and acrobats—appeared in several
drawings from this period, as well as a design for a
drop curtain for the Carbaret Theatre Club
(Victoria and Albert Museum, London). He also
painted a triptych screen with circus performers
and animals for the opening of the Omega
Workshops in July 1913.

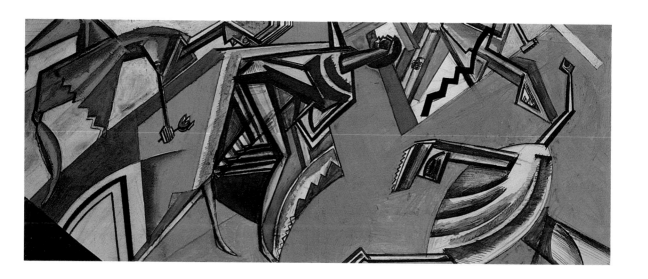

76. *Dancing Figures*

Oil, gouache, crayon, ink, and pencil on paper,
8¼ x 19¾ in.

Signed and dated (at upper left): W L 1914

EXHIBITED: Anthony d'Offay Gallery, London,
1983, *Wyndham Lewis: Drawings and Watercolours
1910-1920*, [n.p.] no. 16 illus. // Anthony d'Offay
Gallery, London, 1984, *The Omega Workshops:
Alliance and Enmity in English Art 1911-1920*,
[n.p.] no. 91 // Washburn Gallery, New York, 1985,
Wyndham Lewis: The Early Decades, [n.p.] [n.n.]
illus. // Palazzo Grassi, Venice, Italy, 1986,
Futurismo and Futurismi, p. 307 illus. // Anthohy
d'Offay Gallery, London, 1986, *Important English
Drawings Relating to Cubism and Vorticism*, [n.p.]
no. 20 // Staatsgalerie, Stuttgart, Germany, 1987,
Englische Kunst im 20. Jahrhundert, [n.p.]
[n.n.] illus.

EX COLL.: private collection; to [The Mayor
Gallery, London, 1978]; to private collection,
London, until 1987

Dancing Figures, a work whose dimensions suggest
its specificity for a particular site, is related to a
mural that Lewis executed either for the Rebel Art
Center or the Restaurant de la Tour Eiffel. The
colors used in this work correspond with
descriptions of Lewis' decorations for the
Restaurant de la Tour Eiffel (executed in 1915),
although the final work appears to have been less
figurative than this drawing.

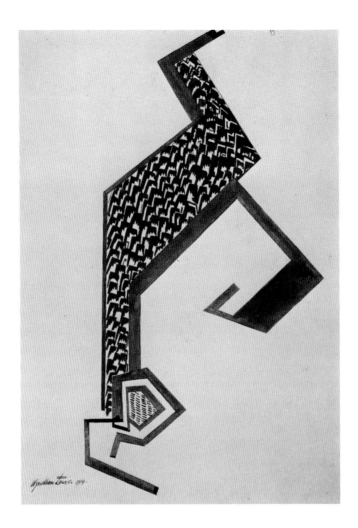

77. *Abstract: Horse*

Ink on paper. 12⅞ x 9⅛ in.
Signed and dated (at lower left): Wyndham
Lewis 1914

RECORDED: Walter Michel, *Wyndham Lewis:
Paintings and Drawings* (1971), p. 358 no. 157
pl. 31, as *Abstract: Bird*

EXHIBITED: Hayward Gallery, London, 1974,
Vorticism and its Allies, p. 78 no. 257, as *Abstract:
Bird* // Anthony d'Offay Gallery, London, 1983,
*Wyndham Lewis: Drawings and Watercolours
1910-1920*, [n.p.] no. 19 illus., as *Abstract: Bird* //
Anthony d'Offay Gallery, London, 1984, *The
Omega Workshops: Alliance and Enmity in English
Art 1911-1920*, [n.p.] no. 94 // Anthony d'Offay
Gallery, London, 1986, *Important English
Drawings Relating to Cubism and Vorticism*, [n.p.]
no. 23 illus.

EX COLL.: the artist; to Walter Michel, until 1984;
to private collection, London, until 1987

A similarly rearing horse appears in Lewis's *Cabaret
Theatre Scene* (cat. no. 75). The compositional
structure of this drawing, with its zig-zag patterns
and acute angularity, is related to other drawings
Lewis executed during this period.

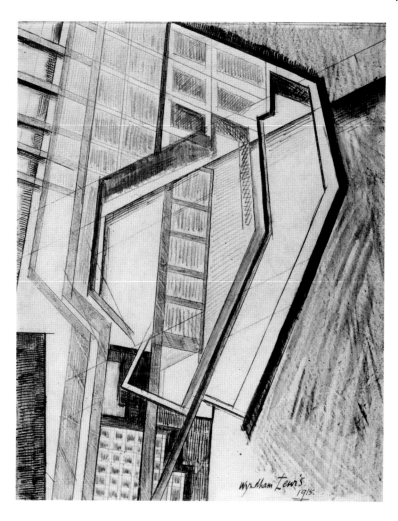

78. *Composition No. 1*

Watercolor, crayon, ink, and pencil on paper,
12¾ x 10¼ in.

Signed and dated (at lower right): Wyndham Lewis
1915

RECORDED: Walter Michel, *Wyndham Lewis:
Paintings and Drawings* (1971), p. 360 no. 176
pl. 28, as *Composition //* Richard Cork, *Vorticism
and Abstract Art in the First Machine Age* (1976),
p. 415 illus.

EXHIBITED: Anthony d'Offay Gallery, London,
1969, *Abstract Art in England 1913-1915*, p. 53
no. 46 illus. // National Book League, London,
1971, *Word and Image I and II: Wyndham Lewis
and Michael Ayrton*, p. 78 no. 11 // Hayward
Gallery, London, 1974, *Vorticism and its Allies*,
p. 78 no. 261 // Davis and Long Company, New
York, 1977, *Vorticism and Abstract Art in the First
Machine Age*, [n.p.] no. 65 // Anthony d'Offay
Gallery, London, 1983, *Wyndham Lewis: Drawings
and Watercolours 1910-1920*, [n.p.] no. 96 //
Anthony d'Offay Gallery, London, 1986, *Important
English Drawings Relating to Cubism and Vorticism*,
[n.p.] no. 26

EX COLL.: the artist; to Michael Ayrton, until
1975; to private collection, London, until 1987

This work following and the works come from
Lewis's "Vorticist Sketchbook," which he kept
between 1914 and 1915. Each of the drawings is
executed in coloured crayon or in pencil with
occasional touches of watercolor. As a whole, they
are predominantly architectural, suggesting the
dynamic mass and rhythm of American
skyscrapers, and expressing Lewis's urban vision
during this time.

79. *Composition No. 2*

Watercolor and pencil on paper, 12 x 9⅞ in.
Executed about 1914-15

RECORDED: *Agenda: Wyndham Lewis Special Issue* (Autumn-Winter 1969-70), p. 34 illus. // Walter Michel, *Wyndham Lewis: Paintings and Drawings* (1971), p. 360 no. 178 // Richard Cork, *Vorticism and Abstract Art in the First Machine Age* (1976), p. 345 illus.

EXHIBITED: Anthony d'Offay Gallery, London, 1969, *Abstract Art in England 1913-1915*, p. 53 no. 47 illus. // Hayward Gallery, London, 1974, *Vorticism and its Allies*, p. 78 no. 262 // Davis and Long Company, New York, 1977, *Vorticism and Abstract Art in the First Machine Age*, [n.p.] no. 66 // Yale Center for British Art, New Haven, Connecticut, 1983, *Blast: The British Answer to Futurism*, [n.p.] no. 4 // Anthony d'Offay Gallery, London, 1984, *The Omega Workshops: Alliance and Enmity in English Art 1911-1920*, [n.p.] no. 97

EX COLL.: the artist; to Walter Michel, until 1968; to private collection, London, until 1987

80. *Composition No. 3*

Watercolor and pencil on paper, 11½ x 10½ in.
Executed about 1914-15

RECORDED: Walter Michel, *Wyndham Lewis: Paintings and Drawings* (1971), p. 360 no. 180 // Richard Cork, *Vorticism and Abstract Art in the First Machine Age* (1976), p. 339 illus. // Seamus Cooney, ed., *BLAST 3* (1984), pl. 3

EXHIBITED: Anthony d'Offay Gallery, London, 1969, *Abstract Art in England 1913-1915*, p. 54 no. 48 illus. // Hayward Gallery, London, 1974, *Vorticism and its Allies*, p. 78 no. 263 // Davis and Long Company, New York, 1977, *Vorticism and Abstract Art in the First Machine Age*, [n.p.] no. 67 // Manchester City Art Gallery, England, National Museum of Wales, Cardiff, and City Art Centre, Edinburgh, Scotland, 1980-81, *Wyndham Lewis*, pp. 69–70 no. 40 illus. // Anthony d'Offay Gallery, London, 1984, *The Omega Workshops: Alliance and Enmity in English Art 1911-1920*, [n.p.] no. 98

EX COLL.: the artist; to Walter Michel, until 1968; to private collection, London, until 1987

81. *Composition No. 4*

Pencil on paper, 11½ x 10 in.
Executed about 1914-15

RECORDED: Walter Michel, *Wyndham Lewis: Paintings and Drawings* (1971), p. 360 no. 181 // Richard Cork, *Vorticism and Abstract Art in the First Machine Age* (1976), pp. 344 illus., 345

EXHIBITED: Anthony d'Offay Gallery, London, 1969, *Abstract Art in England 1913-1915*, p. 54 no. 49 illus. // National Book League, London, 1971, *Word and Image I and II: Wyndham Lewis and Michael Ayrton*, p. 17 no. 12 pl. V // Hayward Gallery, London, 1974, *Vorticism and its Allies*, p. 78 no. 264 // Davis and Long Company, New York, 1977, *Vorticism and Abstract Art in the First Machine Age*, [n.p.] no. 68 // Yale Center for British Art, New Haven, Connecticut, 1983, *Blast: The British Answer to Futurism*, [n.p.] no. 5 // Anthony d'Offay Gallery, London, 1984, *The Omega Workshops: Alliance and Enmity in English Art 1911-1920*, [n.p.] no. 99

EX COLL.: the artist; to Walter Michel, until 1968; to private collection, London, until 1987

79

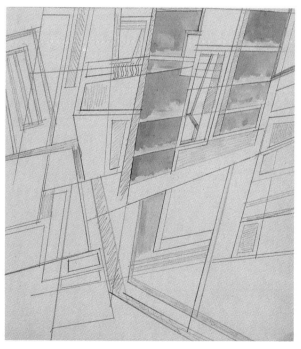

80

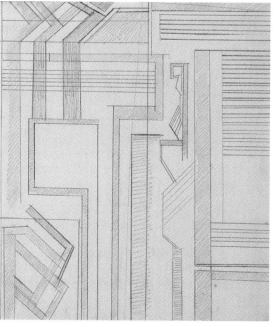

81

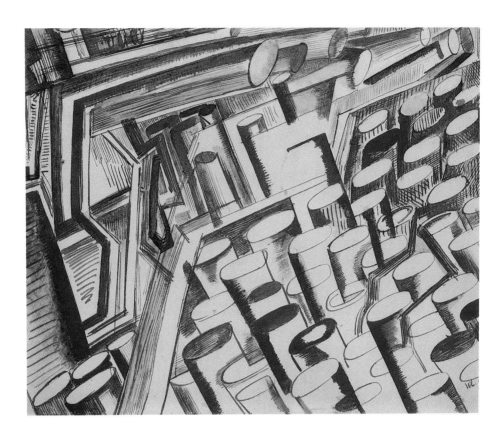

82. *Composition (Soldiers)*

Gouache, ink, and collage on paper, 10¾ x 12¾ in.
Signed and dated (at lower right): W.L. 1915/Jan.

EXHIBITED: American Art Association, New York,
1927, *The John Quinn Collection*, p. 120 no. 293a,
as *Soldiers* // Anthony d'Offay Gallery, London,
1983, *Wyndham Lewis: Drawings and Watercolours
1910-1920*, [n.p.] no. 25 illus. // Washburn Gallery,
New York, 1985, *Wyndham Lewis: The Early
Decades*, [n.p.] [n.n.] illus. as back cover //
Anthony d'Offay Gallery, London, 1986, *Important
English Drawings Relating to Cubism and Vorticism*,
[n.p.] no. 27

EX COLL.: the artist; to John Quinn, New York,
until 1927; to private collection, United States, until
1981; to private collection, London, until 1987

Lewis executed this drawing while he was still in
London, where he organized the first and only
Vorticist exhibition, and edited the second issue of
BLAST. A year after he made this drawing Lewis
volunteered as a gunner and bombardier.
Composition (Soldiers) is among several drawings
which, in their aggressive precision of ranked forms,
anticipate his direct involvement in the War.

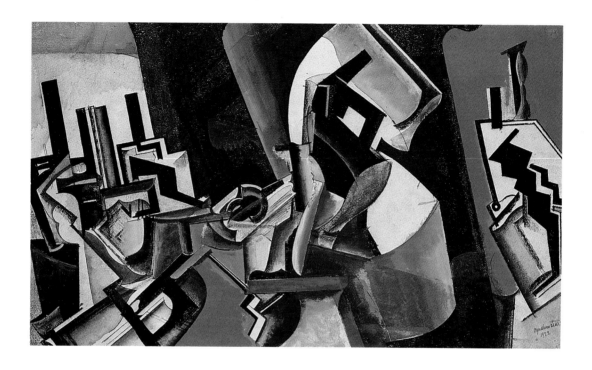

83. *Red and Black Olympus*

Watercolor on paper, 10¼ x 17¼ in.
Executed between 1914 and 1922

RECORDED: *The Tyro No. 2* (1922), [n.p.] illus. //
Walter Michel, *Wyndham Lewis: Paintings and
Drawings* (1971), p. 378 no. 474 pl. 81

EXHIBITED: National Book League, London,
1971, *Word and Image I and II: Wyndham Lewis
and Michael Ayrton*, no. 12 pl. VIII // Manchester
City Art Gallery, England, National Museum of
Wales, Cardiff, and City Art Centre, Edinburgh,
Scotland, 1980-81, *Wyndham Lewis*, p. 94 no. 94
pl. V // Anthony d'Offay Gallery, London, 1984,
Wyndham Lewis: The Twenties, [n.p.] no. 17 illus.
// Washburn Gallery, New York, 1985, *Wyndham
Lewis: The Early Decades*, [n.p.] [n.n.] illus. as
cover // Anthony d'Offay Gallery, London, 1986,
*Important English Drawings Relating to Cubism
and Vorticism*, [n.p.] no. 21 // Staatsgalerie,
Stuttgart, Germany, 1987, *Englische Kunst im 20.
Jahrhundert*, [n.p.] [n.n.] illus.

EX COLL.: the artist; to John Hayward; to Miss G.
Rolleston; to the Hon. David Bathurst; to private
collection, London, until 1987

Begun and completed during an eight-year period,
Red and Black Olympus combines the color and
mood of Lewis's earlier drawings with the figurative
emphasis of his later work, such as *Tyro Madonna*
(private collection, Atlanta, Georgia).

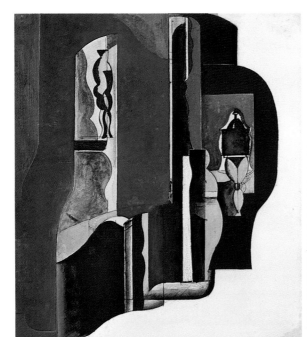

84

84. *Abstract Composition*

Gouache, watercolor, ink, and collage on paper,
10½ x 9¼ in.
Signed and dated (at lower right): Wyndham
Lewis 1921

RECORDED: Walter Michel, *Wyndham Lewis:
Paintings and Drawings* (1971), p. 375 no. 442
pl. 81

EXHIBITED: Tate Gallery, London, 1956,
Wyndham Lewis and Vorticism, p. 18 no. 78, as
Abstract Composition II // Manchester City Art
Gallery, England, National Museum of Wales,
Cardiff, and City Art Centre, Edinburgh, Scotland,
1980-81, *Wyndham Lewis*, p. 89 no. 83 illus.

EX COLL.: the artist; to O. Raymond Drey; to
David Drey; to private collection, London, until
1987

Lewis's "Tyro Portraits", first exhibited at the
Leicester Galleries in 1921, were intended as
satirical inventions, signifying the dehumanization
of people living within the urban environment.
Stylistically this watercolor and its counterpart (cat.
no. 85) belong to this group of works.

85. *Abstract Composition*

Gouache, watercolor, ink, pencil, and collage on
paper, 17¼ x 23 in.
Signed and dated (at lower right): Wyndham
Lewis 1921

RECORDED: Walter Michel, *Wyndham Lewis:
Paintings and Drawings* (1971), p. 375 no. 441
pl. IX

EXHIBITED: Tate Gallery, London, 1956,
Wyndham Lewis and Vorticism, p. 18 no. 77 //
Anthony d'Offay Gallery, London, 1984, *Wyndham
Lewis: The Twenties*, [n.p.] no. 14 illus.

EX COLL.: the artist; to O. Raymond Drey; to
David Drey; to private collection, London, until
1987

86. *Iris Barry Seated*

Watercolor, ink, and pencil on paper,
12½ x 13¼ in.
Signed and dated (at lower right): Wyndham
Lewis 1921

RECORDED: Walter Michel, *Wyndham Lewis:
Paintings and Drawings* (1971), p. 379 no. 496
pl. 49

EXHIBITED: Anthony d'Offay Gallery, London,
1984, *Wyndham Lewis: The Twenties*, [n.p.] no. 7
illus., as *Lady Seated in an Armchair* // Washburn
Gallery, New York, 1985, *Wyndham Lewis: The
Early Decades*, [n.p.] [n.n.] illus.

EX COLL.: [James Graham and Son, New York,
1973]; to private collection, London, until 1987

Between 1919 and 1920 Lewis made an extensive
series of drawings and watercolors of nude models,
and between 1921 and 1923 he executed another
series of figures clothed and seated. Sometimes he
employed professional models; othertimes, his
friends, who included Madge Polsford, the poet and
actress Iris Tree, and the painter Jessica Dismorr, sat
for him. Iris Barry, his mistress at the time, posed for
several other works executed during this period,
Praxitella (Leeds City Art Gallery, England) and
Woman with Red Tam O'Shanter (National Museum
of Wales, England). Barry later became the first
curator of film at The Museum of Modern Art, New
York.

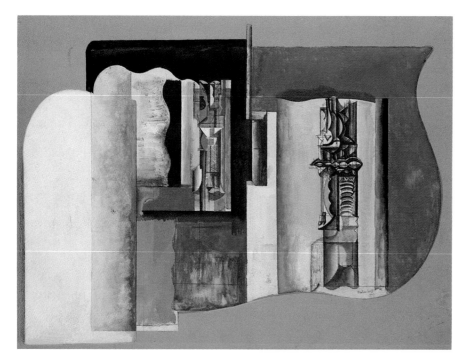

85

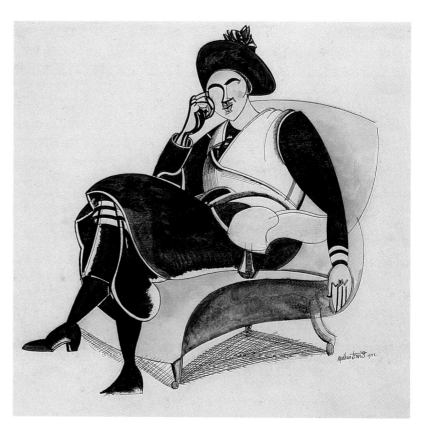

86

87. *Boxing at Juan-les-Pins*

Gouache, watercolor, ink, and pastel on paper,
12½ x 17½ in.
Executed in 1929

RECORDED: Walter Michel, *Wyndham Lewis:
Paintings and Drawings* (1971), p. 391 no. 646
pl. 91 // Wyndham Lewis, *Snooty Baronet* (1984),
p. 168 illus.

EXHIBITED: Anthony d'Offay Gallery, London,
1984, *Wyndham Lewis: The Twenties*, [n.p.] no. 33
illus.

EX COLL.: the artist; to The Earl of Inchcape; to
private collection, London, until 1987

In 1929 Lewis received a commission from The Earl
of Inchcape to execute a series of drawings of
sporting themes. Boxing, wrestling, and beach
games were among the subjects Lewis selected.
Boxing at Juan-les-Pins is part of this series.

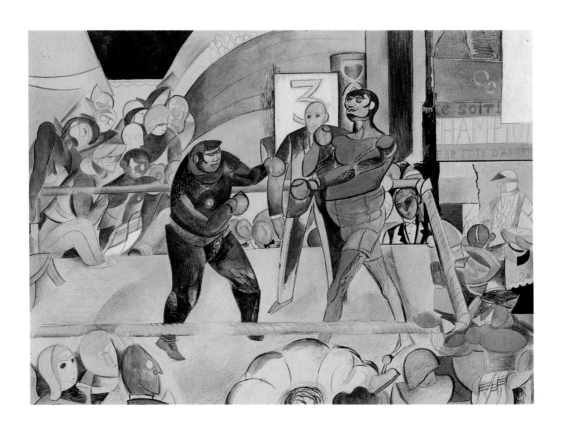

WILLIAM ROBERTS (1895-1980)

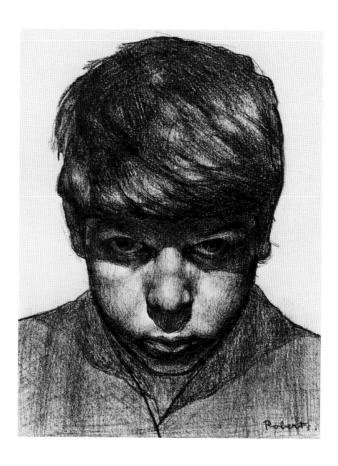

88. *Self-Portrait*

Red chalk on paper, 9⅜ x 7⅜ in.
Signed (at lower right): Roberts
Executed about 1911

RECORDED: Richard Cork, *David Bomberg* (1987), p. 31 no. 31 illus.

EXHIBITED: Anthony d'Offay Gallery, London, 1980, *William Roberts: Drawings and Watercolours*, [n.p.] no. 2 illus.

EX COLL.: the artist; by gift to Dora Carrington; to her brother Noel Carrington, until 1971; to private collection, until 1987

William Roberts lived all his life in London and attended the Slade School of Fine Art, where his fellow students included David Bomberg and Edward Wadsworth. This early *Self-Portrait*, executed while Roberts was at the Slade School, was given to his fellow student at the time, Dora Carrington (cat. no. 115).

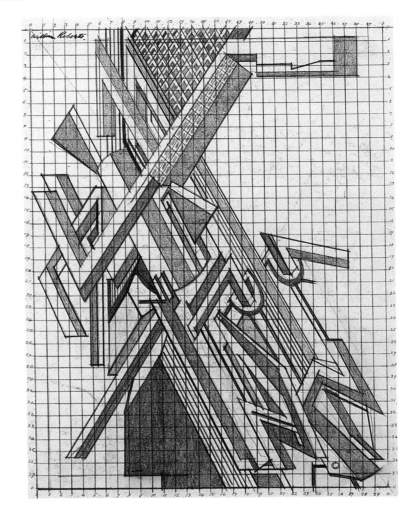

89. *Study for "St. George and the Dragon"*

Pencil on paper, 9½ x 7½ in.

Signed and inscribed (at upper left): William Roberts; (along lower left margin): St. George and the Dragon

Executed about 1913

RECORDED: William Roberts, *Some Early Abstract and Cubist Work 1913-1920* (1957), p. 5 // William Roberts, *Eight Cubist Designs* (1969), [n.p.] pl. 6 // Richard Cork, *Vorticism and Abstract Art in the First Machine Age* (1976), pp. 386, 387 illus., 388

EXHIBITED: Anthony d'Offay Gallery, London, 1969, *Abstract Art in England 1913-1915*, p. 31 no. 32 illus. // Hayward Gallery, London, 1974, *Vorticism and its Allies*, p. 86 no. 342 // Davis and Long Company, New York, 1977, *Vorticism and Abstract Art in the First Machine Age*, [n.p.] no. 41 // Anthony d'Offay Gallery, London, 1980, *William Roberts: Drawings and Watercolours*, [n.p.] no. 6 // Anthony d'Offay Gallery, London, 1982, *British Drawings and Watercolours 1890-1940*, [n.p.]

no. 57 // Yale Center for British Art, New Haven, Connecticut, 1983, *Blast: The British Answer to Futurism*, [n.p.] no. 18 // Palazzo Grassi, Venice, Italy, 1986, *Futurismo and Futurismi*, p. 312 illus. // Anthony d'Offay Gallery, London, 1986, *Important English Drawings Relating to Cubism and Futurism*, [n.p.] no. 28 illus.

EX COLL.: [sale, Sotheby's, London, Dec. 11, 1968, no. 288]; to private collection, London, until 1987

This is a preparatory sketch for a now lost black and white line drawing originally reproduced in a special St. George's Day issue of the *London Evening News* (Apr. 23, 1915), with the caption, "A Futurist St. George." Richard Cork described this work [*op. cit.*, p. 387] as "a classic demonstration of the Vorticist style," where "St. George is quite literally blasted by a Vorticist who sees no reason why such an outdated symbol should be allowed a definite existence outside the harsh reality of the modern world."

90. *La Plage*

Watercolor and ink on paper, 6 x 4¾ in.
Inscribed (at upper right): La Plage
Executed about 1918

EXHIBITED: Anthony d'Offay Gallery, London, 1980, *William Roberts: Drawings and Watercolours*, [n.p.] no. 11 // Davis and Langdale Company, New York, 1984, *British Drawings and Watercolours 1889-1947*, [n.p.] no. 23

EX COLL.: the artist, until 1980; to private collection, London, until 1987

Throughout his career, Roberts' work remained for the most part figurative. While he almost never painted landscapes or still lifes, he investigated a broad range of figurative subjects, from the horrors of war to the pleasures of a holiday, people engaged in sports, at the movies and parties, or playing music. Beginning as early as 1914, he developed, like Fernand Léger, a cylindrical, almost robot-like humanoid image. *La Plage* alludes to the fashionable resorts in the south of France, and is perhaps the first of Roberts' beach scenes.

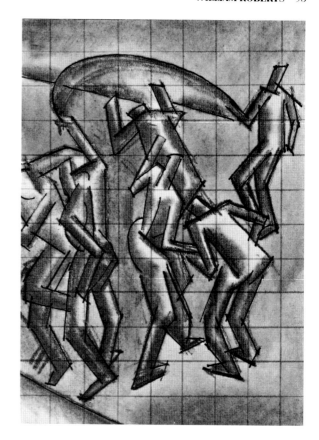

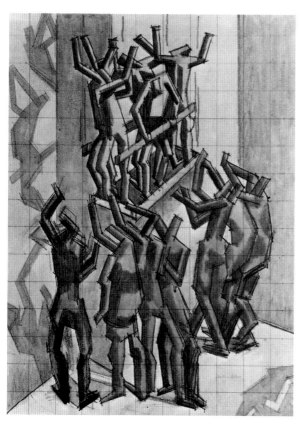

91. *The Builder's Cradle*

Watercolor and ink on paper, 15 x 11 in.
Signed (at lower right): William Roberts
Executed about 1919

EXHIBITED: Davis and Langdale Company, New York, 1984, *British Drawings and Watercolours 1889-1947*, [n.p.] no. 25

EX COLL.: the artist; to Richard Carline; to private collection, London, until 1987

The Builder's Cradle is a preliminary study for the large watercolor, *The Travelling Cradle*, 1920 (Southampton Art Gallery, England).

92. *Behind the Scenes*

Watercolor and ink on paper, 14 x 20½ in.
Signed and dated (at lower right): William
Roberts 1920

RECORDED: William Roberts, *Some Early
Abstract and Cubist Work 1913-1920* (1957), p. 16
pl. 11

EXHIBITED: Chenil Galleries, London, 1923,
Paintings and Drawings by William Roberts, [n.p.]
no. 47 // Tate Gallery, London, Laing Art Gallery,
Newcastle, England, and Whitworth Art Gallery,
University of Manchester, England, 1965-66,
William Roberts Retrospective, [n.p.] no. 139 //
Hamet Gallery, London, 1971, *William Roberts: A
Retrospective Exhibition*, [n.p.] no. 29 // Hamet
Gallery, London, 1973, *William Roberts R.A.*, [n.p.]
no. 21 illus. // Davis and Langdale Company, New
York, 1984, *British Drawings and Watercolours
1889-1947*, [n.p.] no. 24

EX COLL.: the artist, until 1971; to [Hamet
Gallery, London]; to [Maclean Gallery, London]; to
private collection, London, until 1987

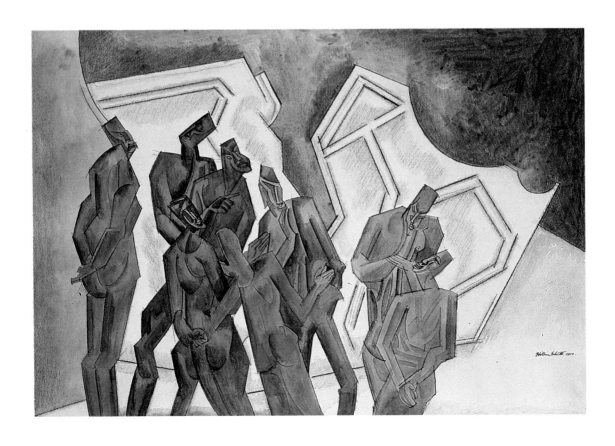

EDWARD WADSWORTH (1889-1949)

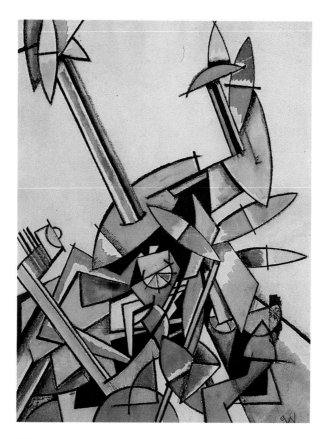

93. *Study for "Cape of Good Hope"*

Watercolor, gouache, ink, and crayon on paper,
13 x 9⅞ in.

Signed with monogram (at lower right): EW
Executed in 1914

RECORDED: Richard Cork, *Vorticism and Abstract
Art in the First Machine Age* (1976), p. 367 illus.

EXHIBITED: Hayward Gallery, London, 1974,
Vorticism and its Allies, p. 83 no. 316 // P. & D.
Colnaghi & Co., London, 1974, *Edward
Wadsworth*, [n.p.] no. 20 illus. // Davis and Long
Company, New York, 1977, *Vorticism and Abstract
Art in the First Machine Age*, [n.p.] no. 44 //
Palazzo Reale, Milan, Italy, 1979-80, *Origini
dell'Astrattismo*, [n.p.] no. 400 illus. // Tate Gallery,
London, 1980, *Abstraction: Toward a New Art*,
p. 108 no. 391 // Yale Center for British Art, New
Haven, Connecticut, 1983, *Blast: The British
Answer to Futurism*, [n.p.] no. 19 // Anthony
d'Offay Gallery, London, 1984, *The Omega
Workshops: Alliance and Enmity in English Art
1911-1920*, [n.p.] no. 109 // Palazzo Grassi, Venice,
Italy, 1986, *Futurismo and Futurismi*, p. 315 illus. //
Anthony d'Offay Gallery, London, 1986, *Important
English Drawings Relating to Cubism and Vorticism*,
[n.p.] no. 30 illus. // Staatsgalerie, Stuttgart,
Germany, 1987, *Englische Kunst im 20.
Jahrhundert*, [n.p.] [n.n.] illus.

EX COLL.: the artist; to A. J. A. Symons, London;
to Julian Symons, London, until 1970; to private
collection, London, until 1987

This is a study for a painting of the same title (now
lost) that was reproduced in *BLAST 1*. When the
painting was shown at the Allied Artists' Salon in
1914, it was highly praised by Henri Gaudier-
Brzeska in *The Egoist* (June 15, 1914). Throughout
his career, Wadsworth found inspiration in the sea,
mercantile ports such as Rotterdam, and fishing
towns such as Cassis. *Study for "Cape of Good
Hope"* is an early sign of this interest, which takes as
its vantage point an aerial view of ships moored at a
dock.

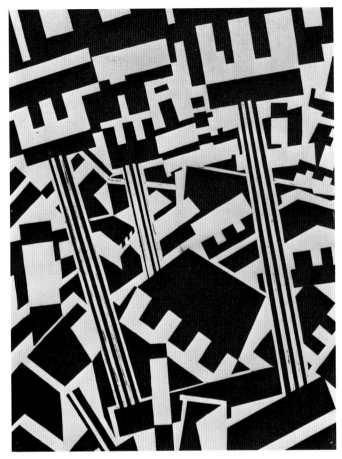

94

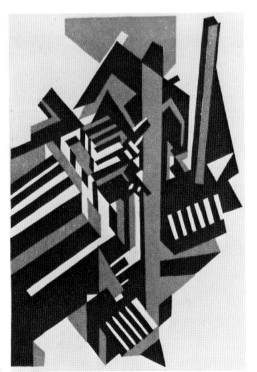

95

94. *Rotterdam*

Woodcut, 10¼ x 7⅞ in.
Executed in 1914

RECORDED: *cf. BLAST 2*, Wyndham Lewis, ed.
(1915), p. 59 illus.

EXHIBITED: *cf.* Doré Galleries, London, 1915,
Vorticist Exhibition, no. A // *cf.* Adelphi Gallery,
London, 1919, *Exhibition of Original Woodcuts and
Drawings by Edward Wadsworth*, [n.p.] no. 7 // *cf.*
Christopher Drake, London, 1973, *Edward
Wadsworth: Early Woodcuts*, [n.p.] no. 1 illus. //
Hayward Gallery, London, 1974, *Vorticism and its
Allies*, p. 96 no. 309 illus. // P. & D. Colnaghi & Co.,
London, 1974, *Edward Wadsworth*, [n.p.] no. 113
illus. // Davis and Long Company, New York, 1977,
Vorticism and Abstract Art in the First Machine Age,
[n.p.] no. 49 // Palazzo Grassi, Venice, Italy, 1986,
Futurismo and Futurismi, p. 626

One of Wadsworth's largest graphic works,
Rotterdam was reproduced full-page in the second
and last issue of *BLAST*. The artist's depiction of
this bustling industrial port, epitomizing the
Vorticist's vision of modern life, was evoked in poetic
verse published in *BLAST 1*, p. 23: "BLESS ALL
PORTS./PORTS, RESTLESS MACHINES, of
scooped out basins/heavy Insect dredgers/
Monotonous cranes/Stations/Lighthouses, blazing/
through the frosty/Starlight…"

95. *Bradford: View of a Town*

Woodcut printed in gray and brown ink on paper,
5⅞ x 4 in.
Executed about 1914

EXHIBITED: *cf.* Adelphi Gallery, London, 1919,
*Exhibition of Original Woodcuts and Drawings by
Edward Wadsworth*, [n.p.] no. 2, as *View of a Town*
// Anthony d'Offay Gallery, London, 1969, *Abstract
Art in England 1913-1915*, p. 32 no. 37 illus. // *cf.*
Christopher Drake, London, 1973, *Edward
Wadsworth: Early Woodcuts*, [n.p.] no. 10 illus. //
cf. Hayward Gallery, London, 1974, *Vorticism and
its Allies*, p. 81 no. 296 illus. on cover // *cf.* P. & D.
Colnaghi & Co., London, 1974, *Edward
Wadsworth*, [n.p.] no. 105 illus. // Davis and Long
Company, New York, 1977, *Vorticism and Abstract
Art in the First Machine Age*, [n.p.] no. 51 // Palazzo
Grassi, Venice, Italy, 1986, *Futurismo and
Futurismi*, p. 626

Wadsworth was born into a prosperous Yorkshire
textile-manufacturing family. The town of Bradford
was the nearest industrial center. As an aspiring
artist, Wadsworth won a scholarship from the
Bradford School of Art to study at the Slade School
in London, where he first met Wyndham Lewis and
other would-be Vorticists. In this print the artist has
transformed the town of Bradford into a dynamic
abstraction.

96. *Episode*

Woodcut printed in brown, gray, and black ink on paper, 4¾ x 4⅜ in.
Executed in 1916

EXHIBITED: *cf.* Adelphi Gallery, London, 1919, *Original Woodcuts and Drawings by Edward Wadsworth*, [n.p.] no. 14 // *cf.* Tate Gallery, London, 1951, *Edward Wadsworth: Memorial Exhibition*, p. 10 no. 89, as *Design* // *cf.* Hayward Gallery, London, 1974, *Vorticism and its Allies*, p. 84 no. 325 // *cf.* P. & D. Colnaghi & Co., London, 1974, *Edward Wadsworth*, [n.p.] no. 117 illus. // *cf.* Davis and Long Company, New York, 1977, *Vorticism and Abstract Art in the First Machine Age*, [n.p.] no. 59

97. *Episode*

Woodcut printed in green, purple, and black ink on paper, 4¾ x 4⅜ in.
Executed in 1916

EXHIBITED: *cf.* Adelphi Gallery, London, 1919, *Exhibition of Original Woodcuts and Drawings by Edward Wadsworth*, [n.p.] no. 14 // *cf.* Tate Gallery, London, 1951, *Edward Wadsworth: Memorial Exhibition*, p. 10 no. 89, as *Design* // *cf.* Hayward Gallery, London, 1974, *Vorticism and its Allies*, p. 84 no. 325 // P. & D. Colnaghi & Co., London, 1974, *Edward Wadsworth*, [n.p.] no. 117 illus. // Davis and Long Company, New York, 1977, *Vorticism and Abstract Art in the First Machine Age*, [n.p.] no. 59 // Palazzo Grassi, Venice, Italy, 1986, *Futurismo and Futurismi*, p. 626

Wadsworth printed his own woodcuts in small, unnumbered editions, and he reportedly burned his printing blocks. Both this and the preceding impression of *Episode*, as experiments in color, are especially rare.

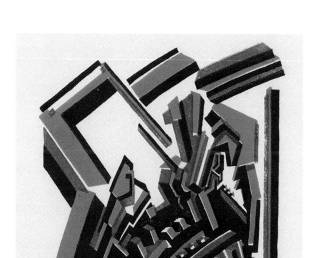

96

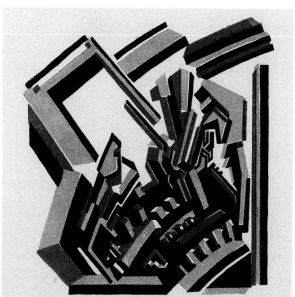

97

98. *Ships Beside Warehouses*

Woodcut printed in black and blue ink on paper,
5¾ x 9⁷/₁₆ in.
Executed in 1918

EXHIBITED: *cf.* Tate Gallery, London, 1951,
Edward Wadsworth: Memorial Exhibition, p. 10
no. 97, as *Dazzle Camouflage—Ships Beside
Warehouses* // *cf.* Christopher Drake, London,
1973, *Edward Wadsworth: Early Woodcuts*, [n.p.]
no. 17 illus., as *Dock Scene* // P. & D. Colnaghi &
Co., London, 1974, *Edward Wadsworth*, [n.p.]
no. 134 illus. // Palazzo Grassi, Venice, Italy, 1986,
Futurismo and Futurismi, p. 626

99. *Drydocked for Scaling and Painting*

Woodcut, 8⅞ x 8¼ in.
Signed (at lower right): Edward Wadsworth
Executed in 1918

RECORDED: *cf.* E. McKnight Kauffer, *The Art of
the Poster* (1924), p. 172

EXHIBITED: *cf.* Adelphi Gallery, London, 1919,
*Exhibition of Original Woodcuts and Drawings by
Edward Wadsworth*, [n.p.] no. 23 // *cf.* Tate Gallery,
London, 1951, *Edward Wadsworth: Memorial
Exhibition*, p. 10 no. 101, as *Stern View of a Ship in
Drydock* // *cf.* Christopher Drake, London, 1973,
Edward Wadsworth: Early Woodcuts, [n.p.] no. 23
illus., as *Camouflaged Ship in Dry Dock for
Repairing* // *cf.* Hayward Gallery, London, 1974,
Vorticism and its Allies, p. 105 no. 459, as
Camouflaged Ship in Dry Dock for Repairing // *cf.*
P. & D. Colnaghi & Co., London, 1974, *Edward
Wadsworth*, [n.p.] no. 129 illus. as cover

Many of the Vorticists served in the armed services
during the First World War. Wadsworth joined the
Royal Naval Volunteer Reserve in the
Mediterranean. He was discharged in 1917, but
continued his involvement by designing camouflage
for war ships docked at Liverpool and Bristol.
During this period he produced an extraordinary
series of seven graphic images of dazzle-ships
(camouflaged boats), of which *Drydocked* is the
most successful.

100. *Industrial Landscape: Tarmac Production*

Ink on paper, 10⅛ x 11¾ in.
Signed and dated (at lower right): Edward
Wadsworth 1919

EXHIBITED: Davis and Langdale Company, New
York, 1984, *British Drawings and Watercolours
1889-1947*, [n.p.] no. 38

In the years following World War I, Wadsworth
painted a series of industrial landscape studies of
the Black Country in the North of England. A
number of these works were subsequently published
by the Ovid Press in a book with an introduction by
the playwright and author Arnold Bennett.

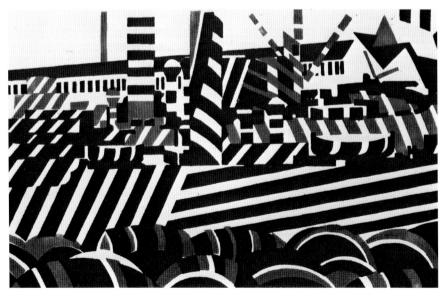

98

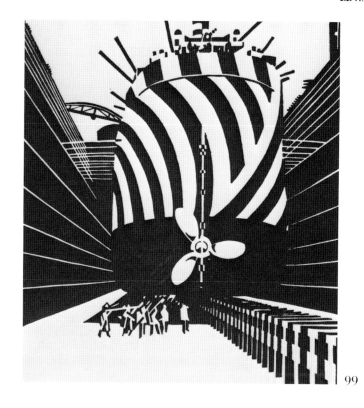

99

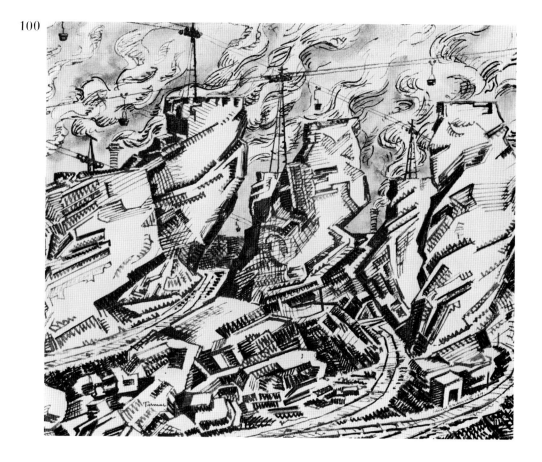

100

Bloomsbury

The Bloomsbury group coalesced around a circle of creative individuals whose collective life style and artistic endeavors produced a unique phenomenon. The group is best known through the novelist, critic, and feminist Virginia Woolf, whose celebrated *Diary* recorded the day to day lives of her husband Leonard Woolf, her sister Vanessa Bell, the painter Duncan Grant, and the critic/artist Roger Fry. Over time the group grew to include the economist John Maynard Keynes, the novelist E. M. Forster, Lytton Strachey, Vita Sackville-West, and T. S. Eliot.

After their father's death in 1904, the sisters Virginia and Vanessa Stephen rebelled against their Victorian upbringing and set up residence in London in the then unfashionable district of Bloomsbury. Virginia wrote and Vanessa painted, and in time both sisters helped to initiate the formation of a group of liberal-minded artists, writers, and political reformers. The Bloomsbury circle expanded when Vanessa married the art critic Clive Bell, and, in 1910, when Roger Fry entered the group. In England, Fry was influential as a critic who organized exhibitions and arbitrated tastes. His efforts were supported by Clive Bell, whose famous defense of Post-Impressionism was published in 1914. Through the critical writings of Fry and Bell, and the informed paintings of Vanessa Bell and Duncan Grant, Bloomsbury became associated with the vanguard art of Henri Matisse and Pablo Picasso. In 1910 and 1912 Fry organized two monumental Post-Impressionist exhibitions at the Grafton Galleries in London. Both shows were landmark events in the history of English culture prior to World War I. They introduced younger painters and an English public to the art of Van Gogh, Gauguin, and Cézanne, as well as to the progressive styles of Fauvism and Cubism. These were exhibitions with a radical purpose; its American counterpart, the Armory Show, would materialize several years later.

The impact of vanguard French painting on the work of Vanessa Bell and Duncan Grant was significant. Grant began to experiment with a number of different techniques and eventually developed a personal style towards the end of the War. Bell's investigation of French modernist painting centered around many sources, particularly the work of Matisse. During this time both painters collaborated with Roger Fry in the formation of the Omega Workshops.

Conceived by Fry as a design center informed by progressive European art, the Omega Workshops produced fabrics, furniture, and interior decoration from 1913 to 1919. The association brought together many vanguard artists, including Bell and Grant, Wyndham Lewis, Henri Gaudier-Brzeska, and William Roberts, and together they designed and decorated tables, screens, and fabrics, and painted monumental murals for their clients' houses. At the Omega showrooms, located at 33 Fitzroy Square, decorative items such as boxes, lampshades, and pottery were displayed along with sculpture by Gaudier-Brzeska and easel paintings by Bell and Grant.

The Bloomsbury Group looked to various sources for inspiration, from Byzantine mosaics and early Italian painting to scenes of contemporary life. Vanessa Bell executed abstract designs for textiles and painted sensuous nudes, flowers, and fruits on furniture and pottery. Duncan Grant drew from a wide repertory of dancers, athletes and swimmers, animals, and exotic flowers, which he incorporated into prescribed spaces, such as a table top, a headboard for a bed, a pencil box or cushion cover. Roger Fry, in addition to administering to the affairs of the Workshops, also designed a line of modern furniture and introduced decorative pottery, whose simplified shapes and clear colored glazes influenced the later development of English ceramics.

When the Omega Workshops finally closed in 1919, Bloomsbury was entering its most productive phase. By then it was a closely knit group of friends working and socializing together. In the years that followed, Woolf, Strachey, Keynes, and Fry published important books, and Vanessa Bell and Duncan Grant exhibited their work internationally in Paris, Venice, and New York. One of their most important decorative programs can still be seen in situ at Charleston, their home in Sussex. Several preliminary studies for work they did at Charleston are included in this exhibition.

Like many English artists of the period, Bell and Grant adapted a more realistic style of painting following the Omega association. They did, however, continue to work as designers, and by the 1930's they were eagerly sought after by commercial manufacturers of carpets, textiles, and painted ceramics. In recent years, following a period of neglect, their paintings and interior decorations have found an enthusiastic public. As a creative unit, their collaborative exchange of ideas epitomized the Bloomsbury way of life.

VANESSA BELL (1879-1961)

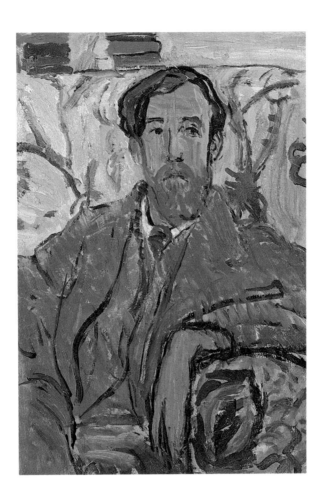

101. *Lytton Strachey*

Oil on board, 14 x 10 in.
Signed (on the back): V. Bell
Painted in 1911

RECORDED: Quentin Bell, *Bloomsbury* (1968),
p. 134 illus. // *Lytton Strachey by Himself*, Michael
Holroyd, ed. (1971), illus. as frontispiece / Francis
Spalding, *Vanessa Bell* (1983), opp. p. 144 illus.

EXHIBITED: Arts Council of Great Britain,
London, 1964, *Vanessa Bell: Memorial Exhibition*,
p. 12 no. 14, dated about 1912 // Royal West of
England Academy, Bristol, 1966, *Paintings by
Duncan Grant and Vanessa Bell*, [n.p.] no. 5 // Rye
Art Gallery, Sussex, England, 1967, *Artists of
Bloomsbury*, [n.p.] no. 21, dated about 1912 //
Davis and Long Company, New York, 1980, *Vanessa
Bell: A Retrospective Exhibition*, p. 12 no. 5 illus. //
Royal Museum, Canterbury, England, 1983,

Vanessa Bell Paintings 1910-1920, p. 9 no. 5 //
Fundacio Caixa de Pensions, Barcelona, Spain,
1986, *El grup de Bloomsbury*, p. 67 no. 19 //
Anthony d'Offay Gallery, London, 1986, *In
Celebration of Charleston*, [n.p.] no. 3

EX COLL.: the artist; to her estate, until 1968; to
private collection, until 1987

An important pictorial document in the history of
Bloomsbury, this portrait of Lytton Strachey
(1880-1932), Duncan Grant's cousin and the
biographer who wrote *Eminent Victorians*, was
painted while Strachey was visiting Vanessa and
Clive Bell at the seaside town of Studland, in Dorset.
In the portrait Bell experimented with a more
colorful palette inspired by her introduction to the
work of the French Post-Impressionists, which had
been exhibited in London the previous year.

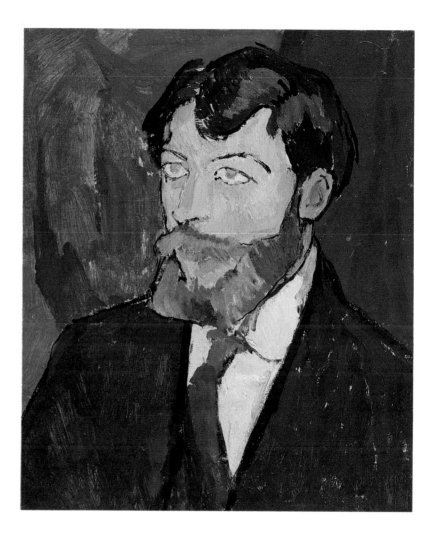

102. *Portrait of Henri Doucet*

Oil on board, 16⅜ x 13⅝ in.
Painted in 1912

RECORDED: Richard Shone, *Bloomsbury Portraits* (1976), pls. 43, 119

EXHIBITED: Miller's Gallery, Lewes, Sussex, England, 1946, *The Omega Workshops*, [n.p.] no. 21 // Arts Council of Great Britain, London, 1964, *Vanessa Bell: Memorial Exhibition*, p. 12 no. 16, dated about 1913 // Fine Art Society, London, 1976, *Bloomsbury Portraits*, [n.p.] no. 5 // Davis and Long Company, New York, 1980, *Vanessa Bell 1879-1961: A Retrospective Exhibition*, p. 16 no. 10 // Royal Museum, Canterbury, England, 1983, *Vanessa Bell: Paintings 1910-1920*, p. 13 no. 15 // Anthony d'Offay Gallery, London, 1984, *The Omega Workshops: Alliance and Enmity in English Art 1911-1920*, [n.p.] no. 3

EX COLL.: the artist; to her estate, until 1970; to private collection, London, until 1987

The French painter Henri Doucet (1883-1915) met Roger Fry in Paris early in 1911 and that summer came to England. The following August Doucet stayed with Vanessa Bell and Duncan Grant at Asheham House, near Lewes, Sussex, at which time they both painted his portrait. In July, 1913, Doucet was in London for the opening of the Omega Workshops, for which he decorated one of the showroom walls. Doucet also exhibited at the second Post-Impressionist exhibition of 1912-1913, and executed additional work for the Omega Workshops during his various visits to London over the next few years. On May 5, 1915, he was killed in the War near Ypres, France.

103. *Adam and Eve and the Serpent: Design for
the Omega Workshops*

Oil, gouache, and pencil on paper, 9¾ x 26¼ in.
Executed in 1913

RECORDED: Quentin Bell, *Bloomsbury* (1974),
opp. p. 48 illus. // Frances Spalding, *Vanessa Bell*
(1983), opp. p. 208 illus.

EXHIBITED: Folio Fine Art, London, 1967,
Vanessa Bell: Drawings and Designs, [n.p.] no. 2 //
Anthony d'Offay Gallery, London, 1973, *Vanessa
Bell: Paintings and Drawings*, p. 44 no. 10 //
National Book League, London, 1976, *The
Bloomsbury Group*, p. 37 no. 88 // Anthony
d'Offay Gallery, London, 1979, *Vanessa Bell:
Paintings from Charleston*, [n.p.] no. 10 // Davis
and Long Company, New York, 1980, *Vanessa Bell
1879-1961: A Retrospective Exhibition*, p. 19 no. 18
// Anthony d'Offay Gallery, London, 1984, *The
Omega Workshops: Alliance and Enmity in English
Art 1911-1920*, [n.p.] no. 10 // Anthony d'Offay
Gallery, London, 1986, *In Celebration of
Charleston*, [n.p.] no. 6

EX COLL.: the artist; to her estate, until 1977; to
private collection, London, until 1987

The biblical story of Genesis figured prominently at
the opening of the Omega Workshops. A pair of
painted curtains depicting Adam and Eve was a
central feature in the grand display, as was the work
of several younger artists, including Duncan Grant,
who contributed *Head of Eve* (Tate Gallery,
London). This design by Vanessa Bell was probably
intended for the headboard of a bed.

104. *Tea in the Nursery*

Oil, gouache, and pencil on paper, 15½ x 27½ in.
Executed about 1915

EXHIBITED: Fine Art Society, Edinburgh,
Scotland, 1975, *Duncan Grant and Bloomsbury*,
[n.p.] no. 37 // Davis and Long Company, New
York, 1980, *Vanessa Bell 1879-1961: A
Retrospective Exhibition*, p. 25 no. 30 // Royal
Museum, Canterbury, England, 1983, *Vanessa Bell:
Paintings 1910-1920*, p. 16 no. 29 // Anthony
d'Offay Gallery, London, 1984, *The Omega
Workshops: Alliance and Enmity in English Art
1911-1920*, [n.p.] no. 18

EX COLL.: the artist; to her estate, until 1970; to
private collection, London, until 1987

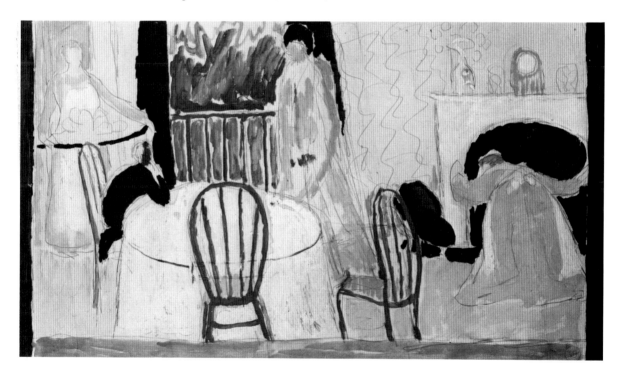

105. *Abstract Composition: Design for the Omega Workshops*

Gouache on paper, 20¾ x 15¾ in.
Inscribed (at lower right): VB
Executed about 1913

EXHIBITED: Hayward Gallery, London, 1974, *Vorticism and its Allies*, p. 48 no. 122 // Anthony d'Offay Gallery, London, 1984, *The Omega Workshops: Alliance and Enmity in English Art 1911-1920*, [n.p.] no. 7 // Fundacio Caixa de Pensions, Barcelona, Spain, 1986, *El grup de Bloomsbury*, p. 30 no. 43 illus.

EX COLL.: the artist; to her estate, until 1970; to private collection, London, until 1987

One of Bell's most successful abstract compositions, this repeat design, originally conceived as a fabric for the Omega Workshops, was never produced. By the winter of 1913-14, with the Workshops' financial reserves exhausted, Roger Fry decided not to extend the range of printed fabrics. Moreover, the outbreak of war in August interrupted textile production in Rouen, France, where Omega's materials were made.

106. *Abstract Composition: Design for the Omega Workshops*

Gouache on paper, 18⅞ x 26⅞ in.
Executed in 1913

RECORDED: Richard Cork, *Vorticism and Abstract Art in the First Machine Age* (1976), p. 89 illus.

EXHIBITED: Hayward Gallery, London, 1974, *Vorticism and its Allies*, p. 48 no. 123 // Davis and Long Company, New York, 1980, *Vanessa Bell: A Retrospective Exhibition*, p. 21 no. 19 // Anthony d'Offay Gallery, London, 1984, *The Omega Workshops: Alliance and Enmity in English Art 1911-1920*, [n.p.] no. 8 // Vassar College Art Gallery, Poughkeepsie, New York, 1984, *Vanessa Bell 1879-1961*, p. 42 no. 6 // Fundacio Caixa de Pensions, Barcelona, Spain, 1986, *El grup de Bloomsbury*, p. 31 no. 42 illus.

EX COLL.: the artist; to her estate, until 1970; to private collection, London, until 1987

In the spring of 1913, Roger Fry encouraged Bell to design a series of linens for the Omega Workshops, so they could be produced in time for their opening on July 8, 1913. Of the six printed linens produced by the Workshops, two are attributed to Bell. This drawing is a design for a linen titled "Maud," named after an early patron of Omega, Lady Cunard, later known as Emerald. The pattern was available in four different color variations.

107. *Abstract Composition: Design for the Omega Workshops*

Oil on paper, 12 x 23¾ in.
Inscribed with Omega symbol (at lower right): Ω
Stamped twice (in the margins): The Omega
Workshops, Ltd./33, Fitzroy Square, W.

RECORDED: Richard Shone, *Bloomsbury Portraits* (1976), pp. 116-17 illus.

EXHIBITED: Hayward Gallery, London, 1974, *Vorticism and its Allies*, p. 48 no. 121 // Davis and Long Company, New York, 1980, *Vanessa Bell 1879-1961: A Retrospective Exhibition*, p. 21 no. 20 // Anthony d'Offay Gallery, London, 1984, *The Omega Workshops: Alliance and Enmity in English Art 1911-1920*, [n.p.] no. 8 // Anthony d'Offay Gallery, London, 1986, *In Celebration of Charleston*, [n.p.] no. 5 // Fundacio Caixa de Pensions, Barcelona, Spain, 1986, *El grup de Bloomsbury*, p. 29 no. 41 illus.

EX COLL.: the artist; to her estate, until 1970; to private collection, until 1987

This design, intended for a carpet, is closely related to Bell's screen titled *Bathers in a Landscape* (Victoria and Albert Museum, London), executed about the same time. Both works were inspired by a camping trip that the artist took in August 1913 with Roger Fry, Duncan Grant, and others, and represent abstracted arrangements of tent poles and canvases.

In March, 1914, Sir Ian and Lady Hamilton commissioned the Omega Workshops to decorate several rooms in their residence at 1 Hyde Park Gardens, London. At least four carpets made from Bell's design were used in their entrance hall. Other examples of this design were displayed in 1914 at the Omega section of the Allied Artists' Salon, Holland Park Hall, London. The same design was also praised by Henri Gaudier-Brzeska in his review of that exhibition which appeared in *The Egoist* (June 15, 1914). A similar, though less finished, design by Bell for the same carpet is in the collection of the Courtauld Institute, London.

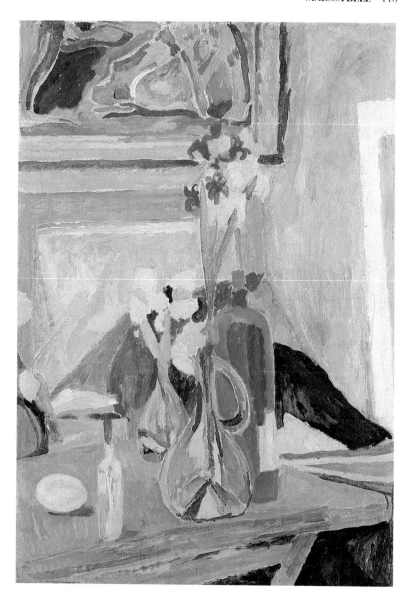

108. *Flowers in the Studio*

Oil on canvas, 31 x 21¾ in.
Painted in 1915

EXHIBITED: Anthony d'Offay Gallery, London,
1986. *In Celebration of Charleston*, [n.p.] no. 8

EX COLL.: the artist; by gift to Virginia Woolf; to
the artist's nephew, Quentin Bell, until 1982; to
private collection, London, until 1987

This painting was given by the artist to her sister,
Virginia Woolf, shortly after it was executed. It hung
for many years in Leonard and Virginia Woolf's
home, Monk's House, in Rodmell, Sussex.

109. *Duncan Grant Painting in a Mirror*

Oil on board, 22¼ x 18 in.
Painted in 1915

EXHIBITED: Arts Council of Great Britain,
London, 1964, *Vanessa Bell: Memorial Exhibition*,
[n.p.] no. 32 // Anthony d'Offay Gallery, London,
1973, *Vanessa Bell: Paintings and Drawings*, p. 45
no. 16, dated 1918 // Fine Art Society, London,
1976, *Bloomsbury Portraits*, [n.p.] no. 12 // Davis
and Long Company, New York, 1980, *Vanessa Bell
1879-1961: A Retrospective Exhibition*, p. 25
no. 28

Lent by The Metropolitan Museum of Art, New York

While there are a substantial number of portraits of
Bell by Grant, only a few are known of Grant by Bell.
In this portrait, which was probably executed in
London late in 1915, Grant is shown painting his
own self-portrait in a mirror.

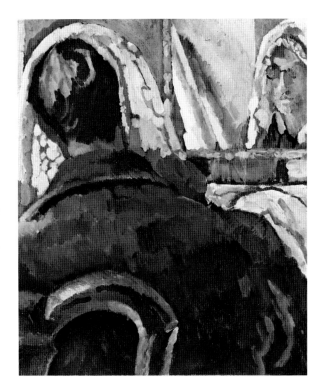

110. *Portrait of Duncan Grant*

Pencil on paper, 22 x 17 in.
Executed in 1934

EXHIBITED: Davis and Long Company, New York,
1980, *Vanessa Bell: A Retrospective Exhibition*,
p. 33 no. 46 // Vassar College Art Gallery,
Poughkeepsie, New York, 1984, *Vanessa Bell 1879-
1961*, p. 15 no. 21 illus.

EX COLL.: the artist; to her estate, until 1987

111. *Portrait of David Garnett*

Oil on board, 30 x 20½ in.

Painted in 1915

RECORDED: Quentin Bell, *Bloomsbury* (1974), pp. 48-49 illus. // Richard Shone, *Bloomsbury Portraits* (1976), p. 140 pl. 97 // Frances Spalding, *Vanessa Bell* (1983), p. 141

EXHIBITED: Anthony d'Offay Gallery, London, 1973, *Vanessa Bell: Paintings and Drawings*, p. 45 no. 15 // Fine Art Society, Edinburgh, Scotland, 1975, *Duncan Grant and Bloomsbury*, [n.p.] no. 36 // Fine Art Society, London, 1976, *Bloomsbury Portraits*, [n.p.] no. 19 // Mappin Art Gallery, Sheffield, England, 1979, *Vanessa Bell: An Exhibition to Mark the Centenary of her Birth*, p. 17 no. 17 // Royal Museum, Canterbury, England, 1983, *Vanessa Bell: Paintings 1910-1920*, p. 19 no. 34 // Anthony d'Offay Gallery, London, 1984, *The Omega Workshops: Alliance and Enmity in English Art 1911-1920*, [n.p.] no. 16 // Nottingham Castle Museum, England, 1985, *D. H. Lawrence and the Visual Arts*, [n.p.] no. 6 // Fundacio Caixa de Pensions, Barcelona, Spain, 1986, *El grup de Bloomsbury*, p. 68 no. 27

EX COLL.: the artist; to her estate, until 1987

Bell painted this portrait of David Garnett at West Wittering, near Chichester, while she and Duncan Grant were staying at Eleanor, a house rented by St. John and Mary Hutchinson. On previous occasions Garnett had posed for Grant, and this time he sat for both artists, probably in Professor Tonk's studio-boathouse on the Chichester estuary, a short walk from Eleanor.

Garnett (1892-1981), who later married Angelica, the daughter of Vanessa Bell and Duncan Grant, was a distinguished figure in the English literary world. He was best known for his novel *Lady into Fox*, and his three volumes of memoires, the first of which, *The Flowers of the Forest* (1955), describes "Eleanor" and the holiday during which this picture was painted.

112

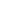

113

112. *Vase of Flowers: Design for the Omega Workshops*

Oil on paper mounted on board, 15 x 37 in.
Executed in 1917

EXHIBITED: Davis and Long Company, New York, 1980, *Vanessa Bell: A Retrospective Exhibition*, p. 27 no. 33 // Anthony d'Offay Gallery, London, 1984, *The Omega Workshops: Alliance and Enmity in English Art 1911-1920*, [n.p.] no. 19 // Vassar College Art Gallery, Poughkeepsie, New York, 1984, *Vanessa Bell 1879-1961*, p. 42 no. 9, illus. as cover // Anthony d'Offay Gallery, London, 1986, *In Celebration of Charleston*, [n.p.] no. 11

EX COLL.: the artist; to her estate, until 1987

The Bloomsbury artists believed in beautifying their environment, and, as part of the general decor of their home, the headboards of their beds were decorated with brightly colored arrangements of flowers and figures. The horizontal format of this painting suggests that it was probably intended as a design for a headboard.

113. *Pineapple and Candlesticks*

Oil on canvas, 8¾ x 17¼ in.
Painted about 1916

EXHIBITED: Fine Art Society, Edinburgh, Scotland, *Duncan Grant and Bloomsbury*, [n.p.] no. 35 // Anthony d'Offay Gallery, London, 1984, *The Omega Workshops: Alliance and Enmity in English Art 1911-1920*, [n.p.] no. 20 // Anthony d'Offay Gallery, London, 1986, *In Celebration of Charleston*, [n.p.] no. 9

EX COLL.: the artist; to her estate, until 1977; to private collection, London, until 1987

This painting was probably intended as a design for the headboard of a bed. The pineapple was an ancient symbol of welcome.

114. *Tiled Table*

Painted ceramic tiles inset into wooden frame,
39 x 27 x 19 in.

Executed between 1930 and 1932

EX COLL.: the artist; to private collection,
England, until 1987

In the early 1920's Vanessa Bell and Duncan Grant
began to paint tiles at a commercial pottery
company in the East End of London. These were
first glazed and fired, and then sold by the artists in
their Christmas studio sales. These tiles could be
purchased individually or in sets, and were then set
into wooden frames for hearths, trays, and sitting-
room tables. Most of the table frames, made to the
artist's specification, were executed by the
cabinetmaker Joseph Kallenborn. This *Tiled Table*
initially retailed for about £10 or £15, a
considerable sum at the time, and very few examples
have survived, especially of Bell's work. A similar
table can be seen in Monk's House, Virginia Woolf's
home in Sussex, England.

DORA CARRINGTON (1893-1932)

115. *Tiles for a Fireplace Surround*

Fourteen painted ceramic tiles,
33 x 30½ in. (overall)
Executed in 1930

RECORDED: Noel Carrington, *Carrington* (1980),
p. 43 illus.

EXHIBITED: Upper Grosvenor Galleries, London,
1970, *Carrington: A Retrospective Exhibition*,
[n.p.] [n.n.] // Bedford Central Library, England,
1979, *Carrington: An Exhibition of Drawings,
Paintings and Decorative Arts*, p. 5 no. 19

EX COLL.: the artist; to private collection, London;
to Mr. and Mrs. Christopher Mason, Brighton,
England, until 1979; to private collection, London,
until 1987

This fireplace surround was originally made for a
private house in Hampstead. It is one of many such
commissions Carrington received during her life-
time, few of which have survived. Like Vanessa Bell
and Duncan Grant, Carrington made decorative
panels, tiles, and objects for her friends. Examples
of these were in Ham Spray House, Berkshire, the
home she shared with Lytton Strachey. Although
Carrington's style is related to the Charleston
artists, her work was more influenced by English
eighteenth-century pottery and Victorian
needlework.

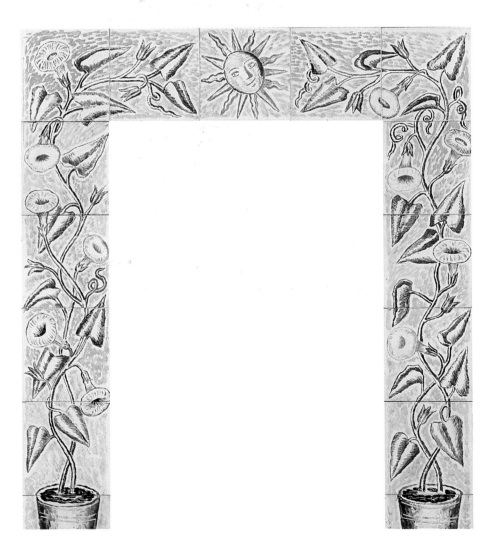

ROGER FRY (1866-1934)

116. *Marquetry Table*

Holly, ebony, and other woods,
27¾ x 28½ x 28½ in.
Executed in 1913

EXHIBITED: Crafts Council Gallery, London,
1984, *The Omega Workshops 1913-1919: Decorative Arts of Bloomsbury*, p. 46 no. F8 illus. // Fundacio Caixa de Pensions, Barcelona, 1986, *El grup de Bloomsbury*, p. 41 no. 54 illus.

EX COLL.: Omega Workshops; to the Mavrogordato family, England, until 1984; to private collection, London, until 1987

The marquetry furniture produced by the Omega Workshops was extremely fine with unusual surfaces and striking designs. A drawing for this marquetry table was illustrated in the Workshops' catalogue in 1913. Even during its day, Omega marquetry furniture was very expensive. There were a limited number of orders for it and the quantity of furniture produced was small. About nine major pieces of marquetry furniture are known, seven of which have survived. This table, with its tray, is the only surviving piece of its kind.

117. *Two Red Omega Dining Room Chairs*

Lacquered wood with cane seats and backs, each
43¼ x 20 x 21½ in.
Executed in 1913

RECORDED: Frances Spalding, *Roger Fry: Art and
Life* (1980), pl. 92 // Isabelle Anscombe, *Omega
and After* (1981), pl. 20 // Judith Collins, *The
Omega Workshops* (1984), pl. V

EXHIBITED: Anthony d'Offay Gallery, London,
1984, *The Omega Workshops: Alliance and Enmity
in English Art 1911-1920*, [n.p.] no. 110 // Fundacio
Caixa de Pensions, Barcelona, Spain, 1986, *El grup
de Bloomsbury*, p. 40 no. 50 illus.

EX COLL.: Omega Workshops; to Roger Fry; to his
daughter Pamela Diamand, until 1983; to private
collection, London, until 1987

Fry designed these dining room chairs in 1913. A set
of six similar chairs, also lacquered in Venetian red,
was purchased by Vanessa Bell and Duncan Grant
in 1916 for their dining room at Charleston, where
they can still be seen today.

118. *Provençal Valley Screen*

Oil and gouache on paper mounted on canvas,
70⅞ x 80⅛ in.
Inscribed with Omega symbol (at lower left): Ω
Executed in 1913

RECORDED: Richard Shone, *Bloomsbury
Portraits* (1976), p. 180 illus. // Judith Collins, *The
Omega Workshops* (1984), pp. 79-81, 207 illus.

EXHIBITED: Alpine Club Gallery, London, 1914,
Second Grafton Group Exhibition, [n.p.] [n.n.], as
Provençal Landscape Screen // The Crafts Council
Gallery, London, 1984, *The Omega Workshops
1913-19: Decorative Arts of Bloomsbury*, p. 38
no. 55 illus.

EX COLL.: Omega Workshops; to Alec Waugh and
thence by descent in the family, until 1987

In the autumn of 1913, Fry and Henri Doucet
painted in the south of France. There, they
discovered a valley near Aramon, a short distance
from Avignon. (On a subsequent visit after World
War I, Fry stayed in the same village.) On October
21, 1919, when he wrote to Vanessa Bell about "his
happy rediscovery of the valley," he also mentioned
this screen: "You remember the screen I painted
from memory of my visit to [the valley] with
Doucet." The *Provençal Valley Screen* is the only
screen that Fry painted for the Workshops. It was
sold to the novelist Alec Waugh, brother of Evelyn
Waugh, during the final sale of Omega's inventory in
1919.

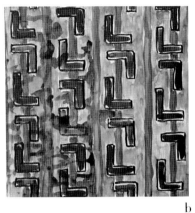

a

b

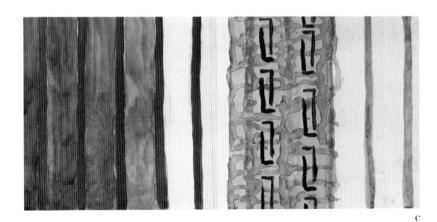

c

119a. *Design for Omega Fabric, "Mechtilde"*
Watercolor and pencil on paper, 6½ x 8¼ in.

b. *Design for Omega Fabric, "Mechtilde"*
Watercolor and pencil on paper, 8 x 8 in.

c. *Design for Omega Fabric, "Mechtilde"*
Watercolor and pencil on paper, 8½ x 16¾ in.
Each executed in 1913

EXHIBITED: Anthony d'Offay Gallery, London,
1984, *The Omega Workshops: Alliance and Enmity
in English Art 1911-1920*. [n.p.] no. 25a-c

EX COLL.: the artist; to Vanessa Bell, and thence
by descent in the family, until 1987

One of six printed linen fabrics for sale at the Omega
Workshops when it opened in July, 1913, *Mechtilde*
was produced in several color variations, and named
after Princess Mechtilde Lichnowsky, the wife of a
German Ambassador who financially supported
Fry's Omega project.

120

121

120. *Omega Writing Case*

Linen-covered book, 9 x 11½ in.
Executed about 1913

EXHIBITED: Anthony d'Offay Gallery, London, 1986, *In Celebration of Charleston*, [n.p.] no. 61

EX COLL.: Omega Workshops; to Duncan Grant, until 1969; to Richard Shone, until 1982; to private collection, London, until 1987

This writing case, intended to hold paper, envelopes, and correspondence, is covered with two versions of *Amenophis*, a linen designed by Fry. Many of the utilitarian objects produced by the Omega Workshops were covered with decorative fabric.

121. *Omega Polar Bear*

Ceramic with white tin glaze, 2⅞ x 5 in.
Inscribed with Omega symbol (on the bottom): Ω
Executed in 1913

EXHIBITED: Anthony d'Offay Gallery, London, 1984, *The Omega Workshops: Alliance and Enmity in English Art 1911-1920*, [n.p.] no. 135

EX COLL.: the artist; to his daughter Pamela Diamand, until 1983; to private collection, until 1987

Small ceramic pieces were popular at the Omega salerooms. Many of these, which in addition to more fragile ceramics, included wooden toy animals with movable limbs and doll houses with furniture, were intended for children. Fry may have designed this *Polar Bear* with his own children, Julian and Pamela, in mind.

OMEGA POTTERY

122a. *Fruit Bowl*
Ceramic with blue cobalt blue glaze, 2⅜ in. high x
8⅛ in. diameter
Incised with Omega symbol (on the bottom): Ω
Executed about 1917-18

EX COLL. (for entries a-m): Omega Workshops; to
Roger Fry; to his daughter Pamela Diamand, until
1980; to private collection, London, until 1987

b. *Vase*
Ceramic with cobalt blue glaze, 5½ in. high
Incised with Omega symbol (on the bottom): Ω
Executed about 1914-15

c. *Vase*
Ceramic with tin glaze and blue overpainted design,
7 in. high
Painted with Omega symbol (on the bottom): Ω
Executed about 1915-16

d. *Jug*
Ceramic with turquoise glaze, 3½ in. high
Incised with Omega symbol (on the bottom): Ω

e. *Vase*
Ceramic with matte green glaze, 5½ in. high
Incised with Omega symbol (on the bottom): Ω
Executed about 1915-16

f. *Inkwell*
Ceramic with white tin glaze, 3⅞ x 8⅜ x 7⅛ in.
Incised with Omega symbol (on the bottom): Ω

g. *Vase*
Ceramic with white tin glaze and blue and purple
over painted design, 3¼ in. high
Painted with Omega symbol (on the bottom): Ω
Executed about 1913-14

h. *Vase*
Ceramic with white tin glaze, 4 in. high
Incised with Omega symbol (on the bottom): Ω
Executed about 1913-14

i. *Tureen*
Ceramic with white tin glaze, 2¾ in. high x 9 in.
in diameter
Incised with Omega symbol (on the bottom): Ω
Executed about 1915

j. *Vase*
Ceramic with white tin glaze and black overpainted
design, 7⅛ in. high
Incised with Omega symbol (on the bottom): Ω
Executed about 1915-16

k. *Cup*
Ceramic with white tin glaze, 2 in. high x 4 in.
in diameter
Incised with Omega symbol (on the bottom): Ω
Executed about 1914

l. *Two Dessert Plates*
Ceramic with cobalt blue glaze, 10 in. in diameter
Each incised with Omega symbol (on the bottom): Ω
Executed about 1914-16

m. *Two Side Plates*
Ceramic with cobalt blue glaze, 8 in. in diameter
Each incised with Omega symbol (on the bottom): Ω
Executed about 1914-16

n. *Two Dinner Plates*
Ceramic with white tin glaze, 12 in. in diameter
Each incised with Omega symbol (on the bottom): Ω
Executed about 1914-16

EX COLL.: Omega Workshops; to Eric Gill, and
thence by descent in the family, until 1982; to
private collection, London, until 1987

o. *Four Soup Plates*
Ceramic with white tin glaze, 11½ in. in diameter
Each incised with Omega symbol (on the bottom): Ω
Executed about 1914-16

EX COLL.: Omega Workshops; to Eric Gill, and
thence by descent in the family, until 1982; to
private collection, London, until 1987

Some of the first ceramics sold at the Omega
Workshops were commercial, utilitarian wares
hand-painted by the artists. Later on Fry started
making his own designs. Initially he preferred a
white tin glaze as a background for simple two color
decorations, and he developed various plain glazes
for plates, vases, and bowls. In the autumn of 1914,
he met the Carter family, master potters living in
Poole, Dorset. With their professional facilities and
expertise, Fry broadened the range and quality of
his wares, and he began producing sets of dinner
and coffee services decorated by Duncan Grant and
Vanessa Bell.

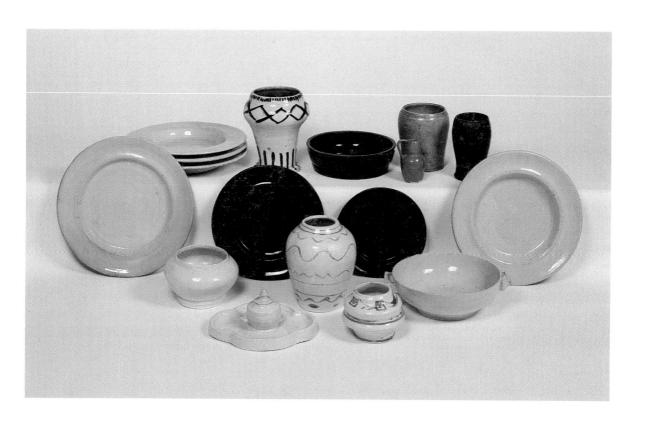

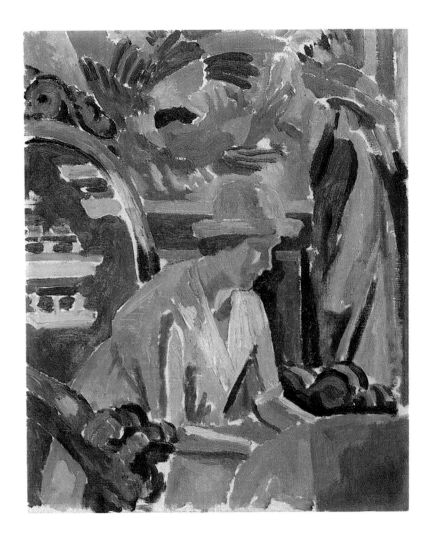

123. *Lady Seated in an Omega Interior*

Oil on canvas. 17½ x 14½ in.
Painted about 1915

EX COLL.: the artist: to Miss Marion Richardson:
to private collection. London, until 1987

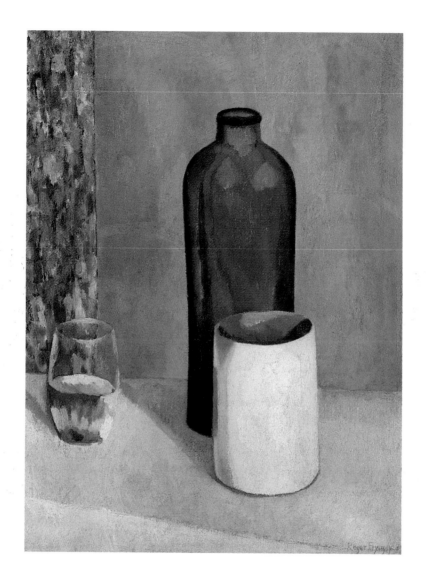

124. *Still Life with Blue Bottle*

Oil on canvas. 23½ x 17¾ in.

Signed and dated (at lower right): Roger Fry 1917

RECORDED: Richard Morphet, "Roger Fry: The Nature of His Paintings," in *Burlington Magazine* (July 1980), p. 486 fig. 26

EXHIBITED: Mansard Gallery, Heals, London, 1917, *The New Movement in Art*, [n.p.] no. 35 // Leicester Museum and Art Gallery, 1919, *Contemporary Art Society Exhibition*, [n.p.] no. 15 // Anthony d'Offay Gallery, London, 1984, *The Omega Workshops: Alliance and Enmity in English Art 1911-1920*, [n.p.] no. 30 // Anthony d'Offay Gallery, London, 1986, *In Celebration of Charleston*, [n.p.] no. 17

Fry sometimes incorporated decorative Omega objects into his still lifes. The blue bottle-shaped vessel in this painting is probably a piece of cobalt glazed ceramic that the Omega Workshops produced from 1915 onward.

DUNCAN GRANT (1885-1978)

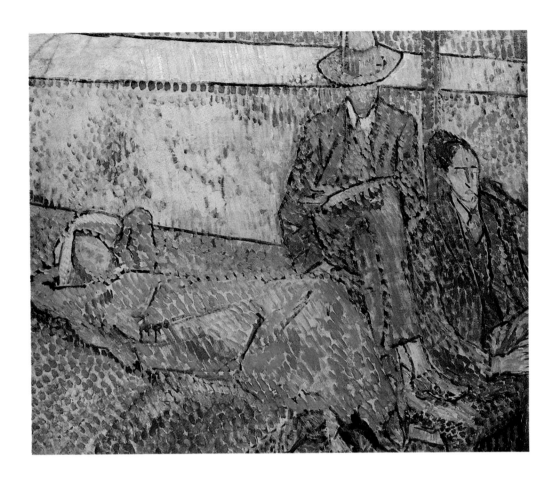

125. *On the Roof, 38 Brunswick Square*

Oil on wood, 38 x 47 in.
Painted in 1912

RECORDED: Richard Shone, *Bloomsbury Portraits* (1976), pl. 1

EXHIBITED: Anthony d'Offay Gallery, London, 1975, *Duncan Grant: Early Paintings*, [n.p.] no. 6 // Scottish National Gallery of Modern Art, Edinburgh, Scotland, 1975, *Duncan Grant*, p. 3 no. 9 // Fine Art Society, Edinburgh, Scotland, 1976, *Bloomsbury Portraits*, [n.p.] no. 35 // Anthony d'Offay Gallery, London, 1984, *The Omega Workshops: Alliance and Enmity in English Art 1911-1920*, [n.p.] no. 47 // Anthony d'Offay Gallery, London, 1986, *In Celebration of Charleston*, [n.p.] no. 21 // Fundacio Caixa de Pensions, Barcelona, Spain, 1986, *El grup de Bloomsbury*, p. 22 no. 18 illus.

EX COLL.: the artist, until 1970; to private collection, London, until 1987

This painting depicts, from left to right, Virginia Stephen, her future husband Leonard Woolf (whom she married in August 1912), and her brother Adrian on the back roof of 38 Brunswick Square, a house they shared at this time with Duncan Grant and John Maynard Keynes. Painted in dabs of unmodulated color, *On the Roof* reflects Grant's adaption of pointillism, a development Vanessa Bell, his lifelong companion, referred to as his "leopard manner."

126. *Vanessa Bell with Yellow Shawl*

Oil on canvas, 23⅜ x 20⅛ in.
Painted about 1911-12

EX COLL.: the artist; to his estate, until 1987

Duncan Grant and Vanessa Bell were introduced in 1905, at a meeting of the Friday Club, an exhibiting society founded by Bell that year. They did not become friends until about 1910, at which time Grant began the first of the many portraits he did of her until her death in 1961. This is almost certainly the first painted portrait Grant made of Bell. Exotic accoutrements, such as shawls and hats, were common features of Grant's early portraits.

127. *Study for Mural: Three Male Nudes*

Oil on board, 29½ x 24½ in.
Inscribed (on the back): 38 Brunswick Sq. WC
Executed about 1911-12

EXHIBITED: Fundacio Caixa de Pensions, Barcelona, Spain, 1986. *El grup de Bloomsbury.* p. 23 no. 34 illus.

EX COLL.: the artist; to his estate, until 1987

In 1912 Grant submitted a design to a London exhibition organized to promote mural decoration in England. Based on the sport of wrestling, this study is probably related to his proposal. From this time on, wrestling and acrobatics continued to be prevalent themes in his work, particularly his designs for the Omega Workshops. Wyndham Lewis and Gaudier-Brzeska also incorporated similar images into their decorative work.

128. *Group at Asheham: Adrian Stephen, Virginia Woolf, Vanessa Bell, and Henri Doucet*

Oil on board, 10½ x 25 in.
Signed, dated, and inscribed (at lower center): 1913/D. Grant/Asheham

RECORDED: John Lehmann, *Virginia Woolf and Her World* (1975), p. 31 illus.

EXHIBITED: Anthony d'Offay Gallery, London, 1984, *The Omega Workshops: Alliance and Enmity in English Art 1911-1920*, [n.p.] no. 49 // Fundacio Caixa de Pensions, Barcelona, Spain, 1986, *El grup de Bloomsbury*, p. 22 no. 33 illus. // Anthony d'Offay Gallery, London, 1986, *In Celebration of Charleston*, [n.p.] no. 22

EX COLL.: the artist; to his estate, until 1970; to private collection, London, until 1987

Grant painted this picture in July or August, 1913, while he was visiting Leonard and Virginia Woolf at Asheham House, in Sussex. He portrayed Virginia Woolf reading on the terrace, with her brother and sister and the painter Henri Doucet, who was visiting from France at the time and was involved in work for The Omega Workshops.

129. *Omega Marquetry Elephant and Rider Tray*

Holly and other woods, 26½ in. in diameter
Inlaid with Omega symbol (on the outside rim): Ω
Executed about 1913-14

RECORDED: *cf.* Richard Cork, *Vorticism and Abstract Art in the First Machine Age* (1976), p. 90 illus. // *cf.* Frances Spalding, *Roger Fry: Art and Life* (1980), p. 115 illus. // *cf.* Isabelle Anscombe, *Omega and After* (1981) pl. 5 illus.

EXHIBITED: *cf.* Hayward Gallery, London, 1974, *Vorticism and its Allies*, p. 49 no. 129 // *cf.* Anthony d'Offay Gallery, London, 1984, *The Omega Workshops: Alliance and Enmity in English Art 1911-1920*, [n.p.] no. 29 illus. // *cf.* The Crafts Council Gallery, London, 1984, *The Omega Workshops 1913-19: Decorative Arts of Bloomsbury*, pp. 50 illus., 54 no. W14

EX COLL.: Omega Workshops; to the Anrep family, until 1987

In 1923 Roger Fry wrote: "When Grant worked at the Omega, some of the designs which he made for carpets, for marquetry, and for needlework represent the high-water mark of applied design in England." Fry published this piece of marquetry in his Omega Workshops catalogue in 1914. As with most of the marquetry furniture produced by Omega, the artist was usually responsible for the initial design, which was then translated into materials by the master cabinet-maker John Joseph Kallenborn. Kallenborn's workshop was located near the Omega Workshops, on Stanhope Street.
(not illustrated)

130. *The Modelling Stand*

Oil and collage on board, 29¾ x 24 in.
Executed in 1914

EXHIBITED: Bluecoat Gallery, Liverpool,
England, and the Brighton Museum and Art
Gallery, England, 1980, *Duncan Grant: Designer*,
p. 15 no. 26 // Anthony d'Offay Gallery, London,
1984, *The Omega Workshops: Alliance and Enmity
in English Art 1911-1920*, [n.p.] no. 59

EX COLL.: the artist, until 1975; to private
collection, London, until 1987

In the early decades of the twentieth century, Grant,
Bell, and Fry experimented with collage. Inspired by
the work of Pablo Picasso and Georges Braque,
these artists began to incorporate fabric, printed
paper, bus tickets, bank checks, and labels into their
work. Grant frequently painted on sheets of paper
which he then cut and pasted on canvas or board.
The Modelling Stand, one of his largest and most
elaborate works in this genre, was also probably
among the earliest. It is stylistically related to
Mantelpiece, about 1914 (Tate Gallery, London).

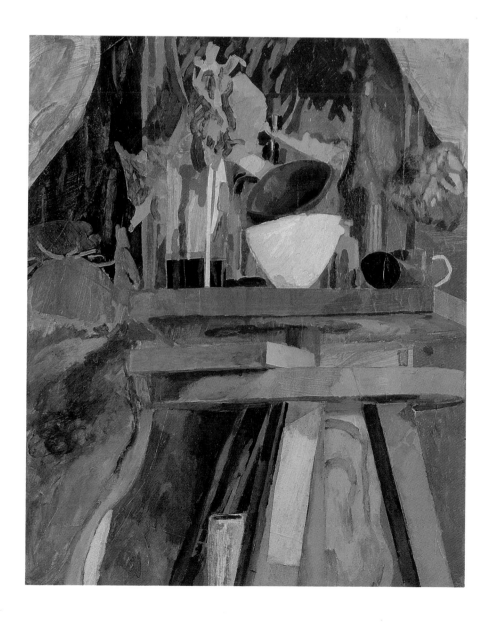

131. *Flowers in a Glass Vase*

Oil on board, 23 x 21¼ in.
Painted about 1917-18

EXHIBITED: Anthony d'Offay Gallery, London,
1984, *The Omega Workshops: Alliance and Enmity
in English Art 1911-1920*, [n.p.] no. 76 // Anthony
d'Offay Gallery, London, 1986, *In Celebration of
Charleston*, [n.p.] no. 30

EX COLL.: the artist; to his estate, until 1987

This work was probably intended as part of a
decorative program, to be inset into a door or
cabinet.

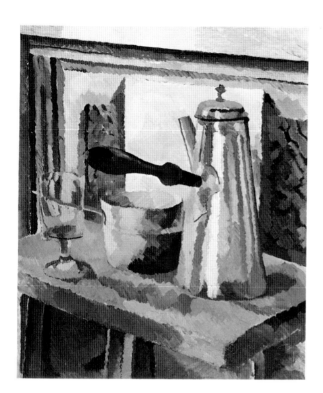

132. *The Coffee Pot*

Oil on canvas, 24 x 20 in.
Executed about 1918

EXHIBITED: Carfax Gallery, London, 1920, *Paintings and Drawings by Duncan Grant*, [n.p.] nos. 9 or 25, as either *Coffee Pot No. 1* or *Coffee Pot No. 2* // Meadows Museum and Gallery, Southern Methodist University, Dallas, Texas, 1984, *The Charleston Artists*, p. 14 no. 19

Lent by The Metropolitan Museum of Art, New York

Grant registered as a Conscientious Objector during the First World War and worked as a farm laborer in Sussex. During this period his painting was restricted to weekends and holidays, and domestic still life became a central motif. A preliminary charcoal drawing for this painting is in the collection of the Cecil Higgins Museum, Bedford, England.

133. *Portrait of Vanessa Bell*

Pencil on paper, 24½ x 18½ in.
Signed and inscribed (at lower right): Duncan Grant/V.B.
Executed about 1920

EXHIBITED: Anthony d'Offay Gallery, London, 1981, *Duncan Grant (1885-1978): Works on Paper*, [n.p.] no. 16

EX COLL.: the artist; to his estate, until 1987

In pose and treatment, this drawing reflects Grant's renewed interest in Cézanne, particularly his portrait of *Mme. Cézanne*, which Grant had copied in watercolor (The Charleston Trust, Sussex, England).

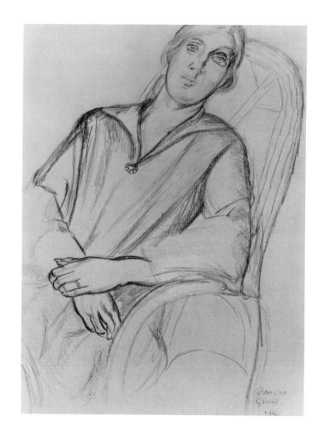

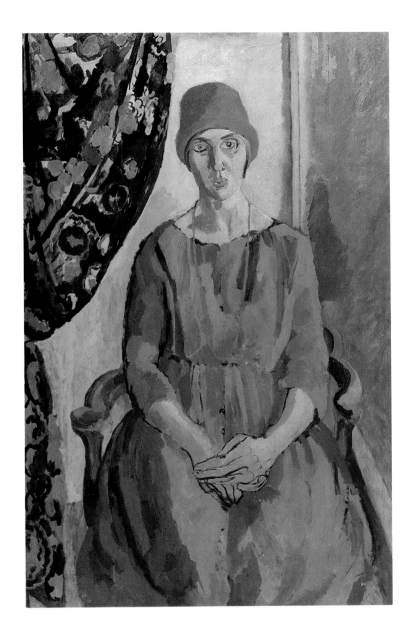

134. *Portrait of Vanessa Bell (The Red Hat)*

Oil on wood, 46½ x 31 in.
Painted about 1917-18

EXHIBITED: The Tate Gallery, London, 1959,
Duncan Grant: A Retrospective Exhibition, [n.p.]
no. 38, dated 1916-17 // Arts Council Gallery,
Cambridge, Laing Art Gallery, Newcastle-on-Tyne,
and University of Hull, England, 1969, *Portraits by
Duncan Grant*, [n.p.] no. 24, as *The Red Hat:
Vanessa Bell*, dated about 1917

EX COLL.: the artist, until 1977; to Richard Shone,
London, until 1987

This is one of the largest portraits of Vanessa Bell
and one of the earliest Grant painted of her at
Charleston. Grant initially began the picture in 1917
and the following year worked it to completion.
More than twenty years later Grant painted another
monumental portrait of Bell in his studio at
Charleston (Tate Gallery, London).

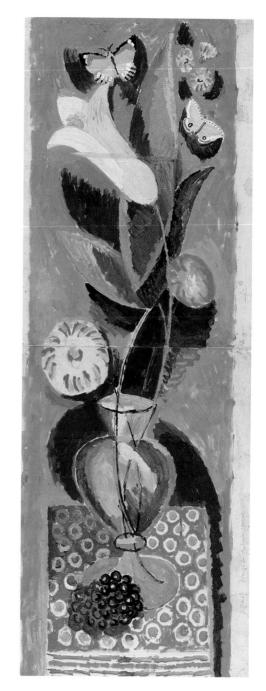

135. *Design for an Embroidered Panel*

Oil on paper, 60 x 18 in.
Signed and inscribed (along left margin): D Grant
Design for Embroidered Panel
Executed about 1926

EXHIBITED: Bluecoat Gallery, Liverpool, and The
Brighton Museum and Art Gallery, England, 1980,
Duncan Grant, Designer, p. 25 no. 56, dated
1926-28

EX COLL.: the artist; to his estate, until 1987

The most elaborate and colorful of Grant's designs
for embroidery, this is the design for a large framed
panel executed in cross stitch by the artist's mother,
Ethel Grant. The finished panel is displayed *in situ*
at the artist's Charleston studio (see photograph on
p. 6).

DUNCAN GRANT (1885-1978) and VANESSA BELL (1879-1961)

136. *Eight Studies for Murals in John Maynard Keynes' Rooms, Webb's Court, Kings College, Cambridge*

Oil on canvas, each 33 x 14½ in.
Painted in 1920

RECORDED: Dorothy Todd and Raymond Mortimer, *The New Interior Decoration* (1929), pls. 24 and 25 // Milo Keynes, "The Picture Collector," in *Essays on John Maynard Keynes* (1975), p. 286 // Richard Shone, *Bloomsbury Portraits* (1976), pp. 234-35

EXHIBITED: Edward Harvane Gallery, London, 1975, *A Homage to Duncan Grant*, [n.p.] no. 7 (one panel) // Bluecoat Gallery, Liverpool, and The Brighton Museum and Art Gallery, England, 1980, *Duncan Grant, Designer*, p. 21 no. 45 (two panels) // Anthony d'Offay Gallery, London, 1984, *The Omega Workshops: Alliance and Enmity in English Art 1911-1920*, [n.p.] no. 78

EX COLL.: the artist; to his estate, until 1987

Although the Omega Workshops closed in 1919, Grant and Bell continued to collaborate on decorative commissions. In 1918, they had decorated Maynard Keynes' sitting room at 46 Gordon Square, and in the summer of 1920, at Charleston, they began eight large panels for Keynes' private rooms in Cambridge. The panels represented the muses of Law, Science, History, etc. Four of these panels covered over a mural that Grant had painted earlier, between 1911 and 1912. The second series of eight panels was installed in 1922. The general theme of these panels, Italianate in feeling with a hieratic figure positioned in a shallow space and outlined against a marbelized background, may have been derived from a reproduction of two fifteenth-century panels of saints by Bono da Ferrara. Ferrara's panels were illustrated in *The Burlington Magazine* (Nov. 1919), a copy of which was at the artist's home. In 1920, the Ferrara panels belonged to Henry Harris, a collector who commissioned the Omega Workshops in 1913 to decorate a room in his house in Bedford Square, London. Another possible source for the murals could have been Andrea del Castagno's series of famous men and women in Santa Appollonia, Florence, Italy, murals that Grant had seen as a young man.

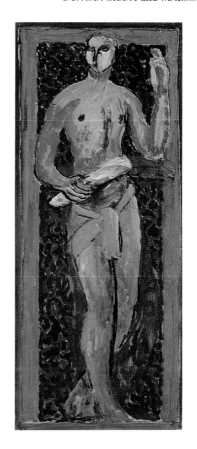

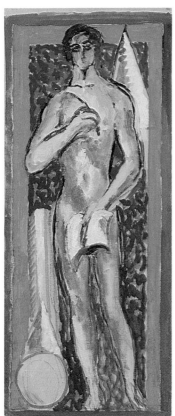

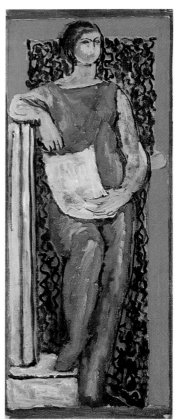

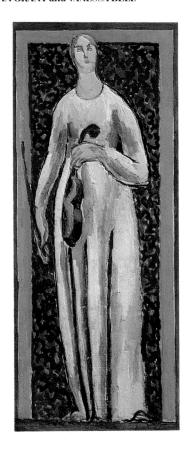

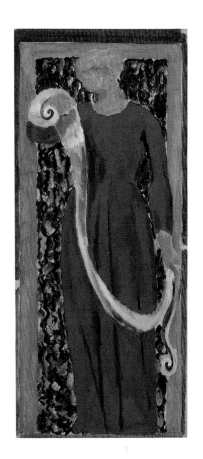

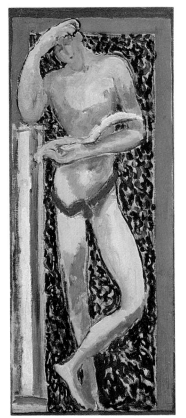

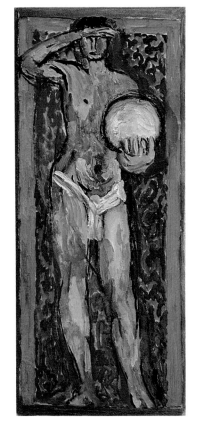

HENRY LAMB (1883-1960)

137. *Portrait of Lady Ottoline Morrell*

Watercolor and pencil on paper, 17¾ x 11⅝ in.
Executed about 1912

EXHIBITED: Anthony d'Offay Gallery, London,
1982, *British Drawings and Watercolours
1890-1940*, [n.p.] no. 39 illus.

Lady Ottoline Morrell, a prominent figure in British
artistic and intellectual circles during the early
twentieth century, was immortalized by D.H.
Lawrence as the outrageous Hermione Roddice in
Women in Love. Lady Ottoline, though not an
intimate member of the Bloomsbury circle, was one

of its most sincere champions and patrons, who
provided financial support and valuable
introductions from her home at 44 Bedford Square
and her palatial country house, Garsington, near
Oxford. Lamb executed two full length drawings of
Lady Ottoline. This drawing was probably done at
Peppard Cottage, Henley-on-Thames, one of the
Morrell's country retreats, where Lamb was
provided with a studio.

STEPHEN TOMLIN (1901-1937)

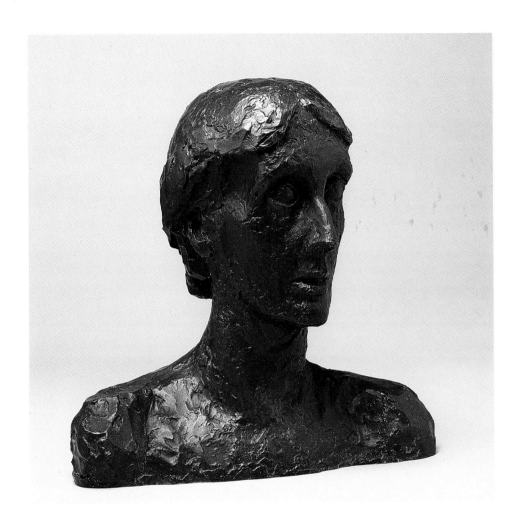

138. *Bust of Virginia Woolf*

Bronze, 16 in. high
Executed in 1931

RECORDED: *cf.* Quentin Bell, *Virginia Woolf* (1972), p. 160 // *cf.* John Lehmann, *Virginia Woolf and her World* (1975), pp. 89, 114 illus.

EXHIBITED: *cf.* The Morris Gallery, Toronto, Canada, 1977, *Artist of the Bloomsbury Group*, [n.p.] [n.n.], illus. as the cover // Anthony d'Offay Gallery, London, 1986, *In Celebration of Charleston*, [n.p.] no. 46

In addition to this work, Tomlin modeled portrait busts of Duncan Grant, David Garnett, and Lytton Strachey. A cast of this subject is in the garden of Monk's House, the Woolf home at Rodmell Sussex; another is in the National Portrait Gallery, London. In 1973, an edition of seven bronzes, of which this is one, authorized by the artist's widow (Lytton Strachey's sister, Julia), were cast from the original plaster (now in Duncan Grant's studio at Charleston).

Index

GALLERY SERVICES

It has occured to us that all too few of our clients have availed themselves of our services in the appraising, restoration and conservation, and framing of works of art. Our expert staff is available at all times to prepare appraisals of single works of art or entire collections. We are also happy to recommend the proper restoration or conservation procedures and to undertake any work that needs to be done. Thomas Cole once wrote, "a frame is the very heart of a picture," and, while we might not fully agree, we would be happy to assist in the selection of appropriate antique frames or museum-quality reproductions that will set off your pictures—oils, watercolors, drawings or prints—to their greatest advantage.

Typesetting by Compo-Set, Inc., New York
Printing by Colorcraft Lithographers, Inc., N.Y.